IMAGES
of America

ROCHESTER'S DUTCHTOWN

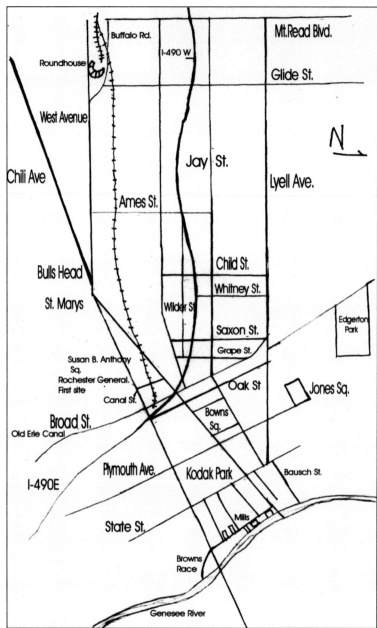

Situated in the northwest section of the city, the old neighborhood is still referred to as Dutchtown long after nearby neighborhoods such as Dublin, Frankfort, Button Hole, and Carthage have dwindled from modern contemplation. The boundaries of the neighborhood tend to expand and contract depending on the storyteller. Today, neighborhood associations proudly support their tracts within the general area. Contemporary boundaries fix the neighborhood within Lyell Avenue, Oak Street, West Avenue, and Mount Read Boulevard. For our purposes, we start at the Genesee River, the High Falls to be exact, since that is where brothers Francis and Matthew Brown established their little industrial village in 1810. Deutschtown—later Dutchtown— evolved within that German settlement. To show how the neighborhood developed, we will look at areas connected to it.

IMAGES
of America

ROCHESTER'S DUTCHTOWN

Michael Leavy and Glenn Leavy

ARCADIA
PUBLISHING

Published by Arcadia Publishing
Charleston, South Carolina

Printed in the United States of America

Library of Congress Catalog Card Number: 2004108957

For all general information, contact Arcadia Publishing:
Telephone 843-853-2070
Fax 843-853-0044
E-mail sales@arcadiapublishing.com
For customer service and orders:
Toll-free 1-888-313-2665

Visit us on the Internet at www.arcadiapublishing.com

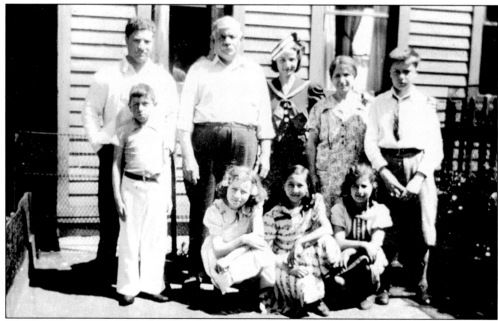

This book is dedicated to the Lombardo family. From their small house on Walnut Street, they endured many trials and reveled in the joys of the old neighborhood, as so many other families have. Pictured along the back, from left to right, are the following: Frank, Matteo, Mary, Mary Angela, and Andy. The kids along the front are Larry and some cousins. Matteo and Mary Angela raised 10 children.

CONTENTS

ACKNOWLEDGMENTS

We appreciate the enthusiastic assistance provided by Cynthia Howk, architectural coordinator for the Landmark Society of Western New York (LSWNY). To those former and present residents of Dutchtown who provided photographs and memories, we hope we have effectively nailed it! The written research includes Rochester history publications by Blake McKelvey. Among those are *The Germans of Rochester: Their Traditions and Contribution*; *The History of Public Health in Rochester, New York*; and *The Italians of Rochester: An Historical Review*. City historian Ruth Rosenberg-Naparsteck provides a stirring historical account in her paper "Frankfort: Birthplace of Rochester's Industry." An article in the July 1988 LSWNY newsletter by Spurgeon King titled "Historic Brown's Race" was particularly useful. Mention must be given to a delightful newspaper article, "Dutchtown is Still Dutchtown Despite the Passing Years," written by Howard H. Kemp and published on April 23, 1933. The Rochester images Web site with its histories was very useful. We are grateful to Thomas DellaPorta for his contributions.

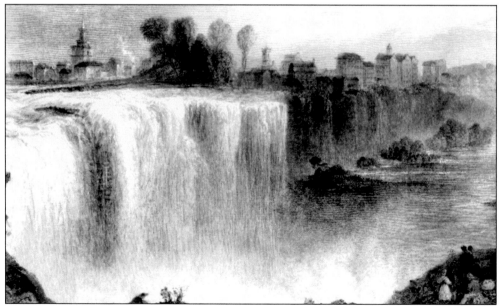

Beginning in the 1640s, the remarkable scenic beauty of the Genesee Falls came to be known worldwide through renderings done, for the most part, by French explorers. This beautiful engraving was done in London *c*. 1840. It depicts some of the early mills along Brown's Race.

INTRODUCTION

Francis Brown, last from Detroit, was a passenger bound for Rome, New York, in 1810 when the vessel was shipwrecked near Niagara. Barely making it to shore, the hearty 21-year-old set off the next day in a canoe. He had reached the mouth of the Genesee River when a sudden Lake Ontario squall forced him to turn out of the lake and into the river's gorge. Perhaps anxious for the solidness of land, he walked from the Lower Falls along the river's bank until he reached the Harford gristmill at the Upper Falls, a dreary, muddy place where distant farmers brought their wheat to be ground. The roar of the cascade and bellowing of the storm excited him, and he quickly saw great potential in the mighty natural power of the falls.

When he got to Rome, he fervently discussed this with his physician brother, Matthew. They agreed to make an offer for the mill to owner Charles Harford, who, it turned out, was only too happy to sell it. Attracting two additional investors, the Browns purchased the mill and 200 acres north of the original 100-acre tract then being developed by three Maryland gentlemen: Rochester, Fitzhugh, and Carroll.

The mill site was named Frankfort, after Francis, and the brothers soon lorded over a thriving little industrial community. They built themselves houses; Francis put his on a hilltop where North Plymouth Avenue and Brown Street later intersected. From it he could see Brown Square, a public commons they laid out. Meanwhile, Brown's Race was being painstakingly blasted out of the rock along the Genesee gorge to power additional mills.

The end of the War of 1812 eliminated British threats in the region, and settlement began in earnest. German immigrants were drawn to Frankfort, but like rival settlements at Carthage, Hansford Landing, and Charlotte, its shipping aspirations were dealt a blow when Colonel Rochester prevailed in routing the Erie Canal through his village. Shipping on the canal was cheaper, safer, and faster than shipping on the lake. By 1817, Frankfort was annexed into an astonishingly successful Rochester but retained its own identity.

Brown's Race remained the industrial hub of the city, and the brothers worked with Colonel Rochester on many civic improvements, even becoming active politically. Residential streets and squares were laid out west of Brown's Race. A large population of Irish immigrants moved in and established St. Patrick's Church.

Throughout the 1830s and 1840s, canals and railroads pierced the neighborhood, transporting freight from Brown's Race. The German predominance in the expanding neighborhood in the early and mid 19th century led to the name Deutschtown (Germantown). This was difficult to pronounce for other ethnic groups, and it eventually transformed into Dutchtown, even though hardly a soul from Holland lived there.

In the late 19th and early 20th centuries, waves of Italian immigrants moved to Rochester. Some families came together, but in other cases, sobbing parents at Italian ports put their children aboard American-bound ships knowing they might never see them again.

These "Romans, who carry knives," were openly despised in many quarters. Businesses wouldn't hire them. Churches, charities, and Italian societies helped those most desperate. In 1889, Italian matrons organized the Italian Mission to help establish a cultural foothold. A blending of cultures occurred when a patriotic society, Bersagliere La Marmora, was allowed to celebrate in Germania Hall. But hostility against the Italians continued until World War II, when factories, desperate for laborers, set aside foolish prejudices and hired them by the thousands. In the 1950s, African Americans and Puerto Ricans began moving in as the Italians moved to nearby suburbs.

Dutchtown has always been a tough neighborhood. It was, in the truest sense, an American melting pot where ethnic groups learned to overlook their differences and work together for the common good, all while maintaining their homeland traditions. The neighborhood could have been transplanted into any industrial city and easily taken root.

Though never quite as opulent as surrounding wards, Dutchtown had its own working-class appeal. Everything one needed was within walking distance, including small industries, schools, and churches. A corner dry-goods store, bakery, saloon, or butcher shop was never far away.

For tens of thousands of regional families who can trace their forebears back to its modest streets, Dutchtown remains a beloved neighborhood. It is also Rochester's most historic neighborhood. Within it lies the area's oldest industrial artifacts.

The mention of Dutchtown brings smiles to the faces of old-timers. Some, whose memories are used in this book, recall vividly the horse-and-buggy days. Their eyes light up with a deep richness as they go back, in some cases, 80 years to their childhoods. They remember the sounds of vendor wagons on brick-paved Jay and Maple Streets, the charging of fire horses down Orange Street, the clatter of trolleys on Lyell Avenue, and the rumble of steam engines at the Hague Street tracks. The clanging of shop doorbells when they entered with their pennies for candy or Christmas decorations is still sharp in their minds. The smells of schnitzel and Limburger were later joined with Italian fragrances of pasta and garlic.

The Germans grew cabbage in their small yards, while the Italians tended their tomatoes. Most families raised chickens, and a tree stump made a suitable chopping block. Those with larger yards had cows. Saloonkeepers joked about "Frog Leg" George, who sold frog legs on Front Street. His smelly cart was a common sight in Dutchtown, where he would sometimes startle curious children by eating a live frog. Barbers liked to boast about Big League greats like Heinie Groh, revered as the "Pride of Dutchtown."

Stories of childhood illnesses, bitter ethnic rivalries, weddings, wars, holidays, and the Great Depression are told here. For nearly two centuries, this colorful, many-layered neighborhood has been home to the area's most industrious people. Many lived totally for their children and for America. When they came here they had nothing. Now look at what they made from it.

One

ORIGINS OF AN INDUSTRIAL
VILLAGE BESIDE THE GENESEE

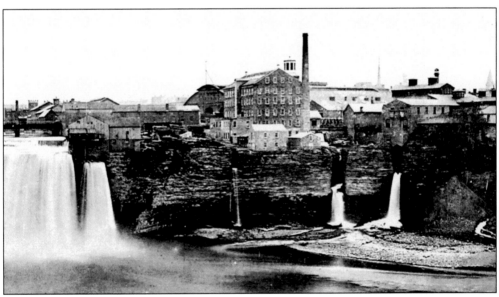

Dutchtown's roots actually reach deep within the bedrock of Brown's Race. Without the mills, the neighborhood would still have existed, but not with the history residents today know it for. Spillways gouge the stone canyon like fingers in an implacable grip. The Brown brothers and partners John McKay and Thomas Mumford purchased Harford mill and an additional 200 acres north and west of Rochesterville in 1810. They quickly established an industrial village along the gorge that would ultimately give Rochester preeminence in the Genesee region as an industrial and trading giant. In 1815, the brothers started the Genesee Manufacturing Company to exploit the tremendous force of the cascade. This image from the 1870s shows an impressive cluster of 19th-century industrial structures.

Francis Brown named the settlement Frankfort after himself. This mill was typical of the vernacular industrial style found along waterways, particularly in New England. It could produce up to 150 barrels of flour a day on three run of stones. Adjacent mills included the Clinton Mills with four run of stones, Washington Mills, Shawmut Mills, Boston Mills, New York Mills, Phoenix Mills, Cataract Mills, and the powerful Granite Mills, which could produce up to 600 barrels a day with its run of 10 stones.

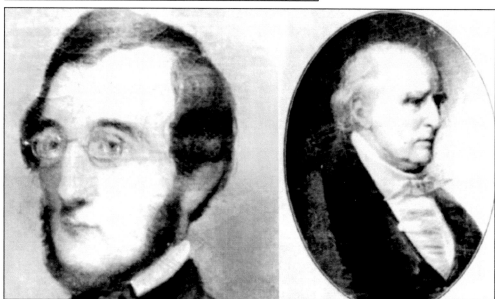

It is accepted that the gentleman on the left is Francis Brown Jr. He shared his father's enthusiasm for Brown's Race and Frankfort. On the right is Matthew Brown, who invested in the mill site with his brother, Francis Brown Sr. The Harford Mill they purchased stood at the intersection of Mill and Platt Streets, where the Phoenix Mill still stands. They also purchased 200 acres adjacent to the mill. Although the area was a rugged wilderness then, they knew it had more potential than the 12-foot falls to the south where Colonel Rochester was staking his hopes.

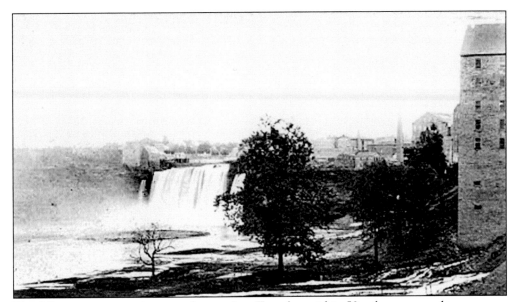

The falls were a spectacular natural attraction. Travelers within 50 miles attempted to come see them. Train service, which began in the 1840s, brought spectators from afar. Falls Field, located on the east side of the gorge, became a favorite parade and circus ground. In the 1930s it had become an embarrassing junkyard, and a pedestrian bridge along the New York Central Railroad bridge that provided a thrilling vantage of the falls had deteriorated and was demolished. The landscape in this c. 1880 stereo view is deeply rutted from mill spillways.

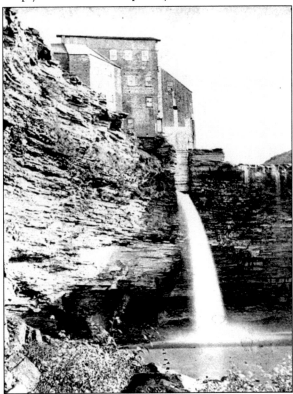

A c. 1870 stereo view shows a spillway and the dense rock into which the Brown brothers had contractors blast and chisel their millrace. It was completed in 1816 along the western rim of the gorge. Originally, it was slightly over 1,200 feet long; it was later expanded to 1,386 feet. Cutting the millrace, which was 30 feet wide and 5.5 feet deep, was a remarkable and exhausting effort. By 1820, it was powering one flour mill, a cotton mill, two sawmills, a distillery, and a scythe mill. More millraces would be cut on both sides of the gorge.

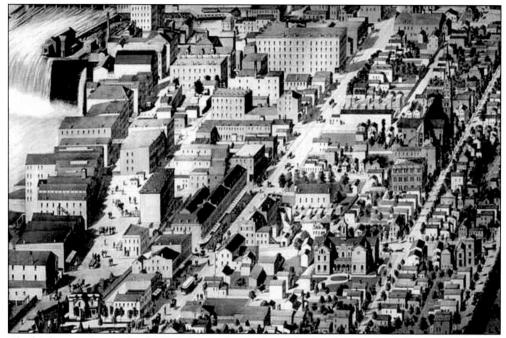

The bird's-eye view in this 1870s lithograph reveals much. On the extreme left are the falls. The mills along Brown's Race are along the river. State Street runs through the center of the picture, and to the right are some of the residential streets within Frankfort. There were boarding houses and tenements within the milling complex that were used by the poorest families. As the area became increasingly industrialized, it grew less appealing as a neighborhood, giving rise to the Dutchtown area.

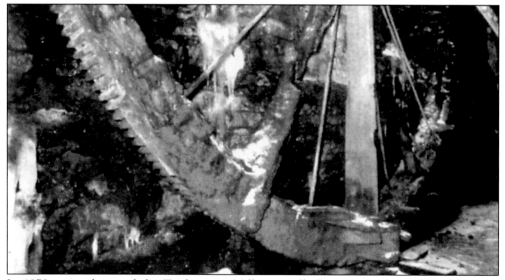

In 1978, arson destroyed the Triphammer Mill, originally Brown's Scythe and Tool Factory. During partial demolition of the ruin in 1983, crews discovered this massive cast-iron and wood waterwheel sealed in a chamber 40 feet below street level. When steam power made these wheels obsolete, it was easier to seal them in their pits rather than dismantle them. The discovery of this c. 1826 industrial relic drew national attention. (Courtesy Rochester Public Library.)

A reconstructed wheel based on the fragments of the original structure is now on display. The stabilized remnants of the Triphammer Mill, now part of the High Falls entertainment district, provide a fascinating look back at how these mills were painstakingly built. The original four-story structure was 20 bays deep. A torrent of water was released from the race to get the main wheels turning. Smaller wheels and equipment could be engaged as the water flooded through the remaining chambers. It then emptied into the gorge through spillways.

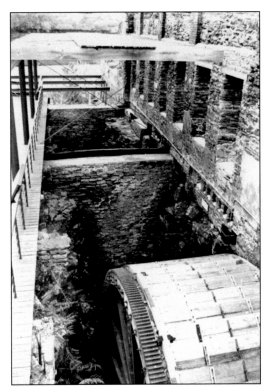

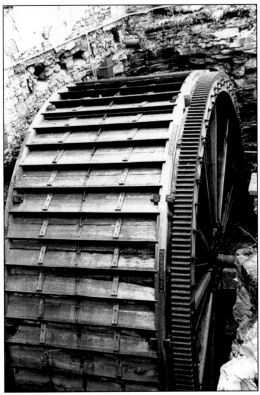

A closer look shows details of the reconstructed wheel. Once rolling, these wheels powered atmospheric triphammers as well as factory drive belts and large machinery. A network of pinion gears and shafts allowed the powering of mills across the race. Earlier tub wheel systems were clamorous. Edwin Scrantom wrote of them, "If it became necessary to stop the mill before night, it was done by letting the [grinding] stones together, which produced a great roar, and made a sulphurous smell in the mill almost stifling to one's breath." The roar of the falls, together with the bawling of workers, the growl of turning wheels, and the rhythmic thumping of triphammers, must have made the little industrial village a place where it was hard to catch 40 winks.

13

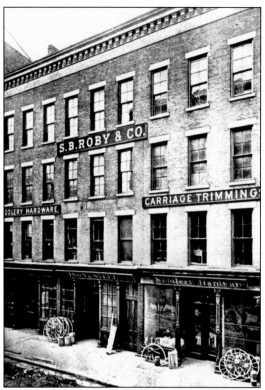

The S. B. Roby and Company building stood at 67, 69, and 71 Mill Street. Situated within the Brown's Race district, Roby's supplied saddlery hardware, carriage wheels and trimmings, and blacksmith supplies. When Rochester won the right of way for the Erie Canal, those at Frankfort were disappointed because it ended their hopes of dominating shipping. Canal transportation was preferable to river use. However, the canal brought an unprecedented boom to the region. Frankfort was annexed to Rochesterville in 1817, but managed to keep its own identity. This view of a prosperous Roby's dates to the 1890s.

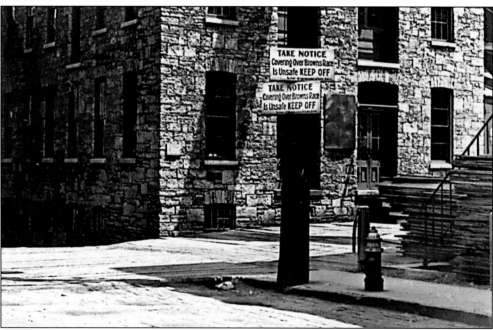

This *c.* 1916 photograph shows the initial stress that automobiles and trucks put on the small industrial area along the gorge. The millrace had a wooden deck over it, which needed constant maintenance. The sign warns, "Take Notice. Covering Over Brown's Race is Unsafe. Keep Off." (Courtesy Irondequoit Chapter D.A.R.)

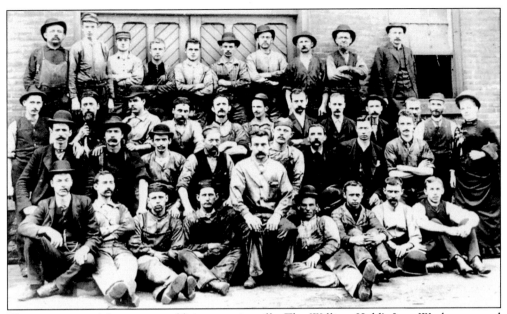

The race powered factories in addition to gristmills. The William Kidd's Iron Works operated on the corner of Brown's Race and Commercial Streets from 1836 to 1874. William Gleason, a superintendent of the company, bought the business and developed it into Gleason Works, a manufacturer of beveled-gear grinding machines. This photograph of workers dates to the late 1870s. Some were Irish immigrants from the nearby settlement of Dublin; others were Germans from Deutschtown.

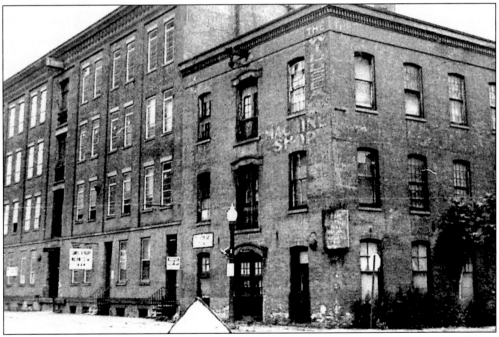

These two Mill Street industrial buildings were home to numerous companies, including a machine shop. Note the old streetlight. This image dates to the early 1970s. (Courtesy Landmark Society of Western New York.)

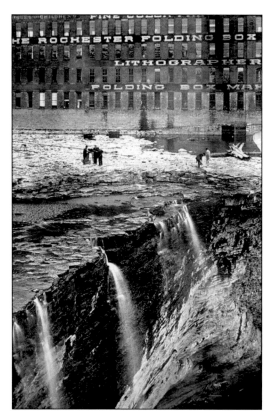

A c. 1914 view looking west towards the Gorsline Building shows civil engineers taking advantage of the low river level to set dynamite charges, deepening the riverbed as a method of flood control. Flooding along the Genesee River was a severe problem, especially during the spring thaw. The Romanesque style Gorsline Building, dating to 1889, was constructed over the earlier Parson sawmill. William Hoyt and Company Shoe Factory, one of many in the area, leased space there and employed hundreds of German immigrants who had brought their handcraft skills to America. (Courtesy Rochester City Hall Photo Lab.)

The Selye Fire Engine Factory at 208 Mill Street was built in 1826 and survives as a classic example of the industrial vernacular style. It features recessed bays and segmental arched windows. It was built on the west side of the race. Power was transferred to it across the race from a linkage system connected to the Triphammer Mill. Note the transfer deck and walkway extending between the two buildings seen in this c. 1917 image. (Courtesy Irondequoit Chapter D.A.R.)

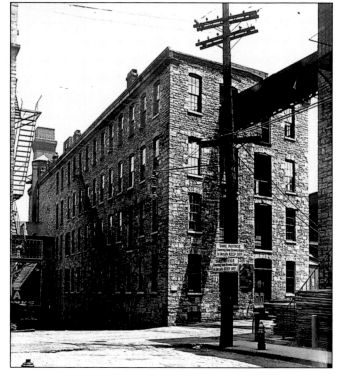

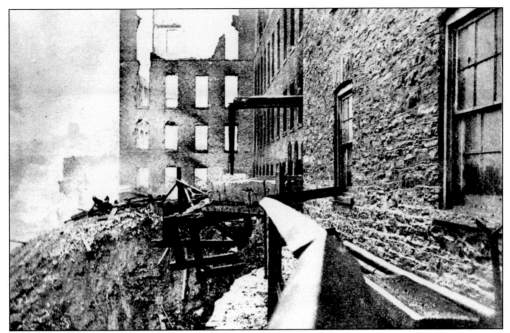

During the night of November 9, 1888, a devastating fire swept through the Steam Gauge and Lantern Works in the Gorsline Building. Approximately 60 workers became trapped. Some jumped to waiting blankets held by firemen; others climbed down ladders set outside windows. Surrounded by flame and smoke, others jumped out of windows and plunged down the gorge. In total, 34 workers died in one of worst of several disasters that brought about new firefighting and safety measures. This photograph was taken the morning after the fire. (Courtesy Rochester Public Library Local History Division.)

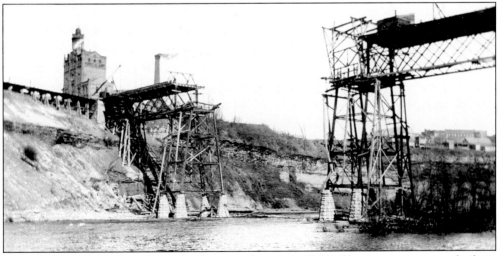

Construction of the Platt Street Bridge is underway in 1891. The impressive span, built in the heart of the Brown's Race complex, was used until 1968, when it was closed to car traffic because of deterioration. It was repaired and relegated to pedestrian use as the Point De Rennes Bridge in honor of our sister city in Rennes, France. For generations it was used by Dutchtown residents going to work at Bausch and Lomb and breweries along the gorge. (Courtesy Rochester Public Library Local History Division.)

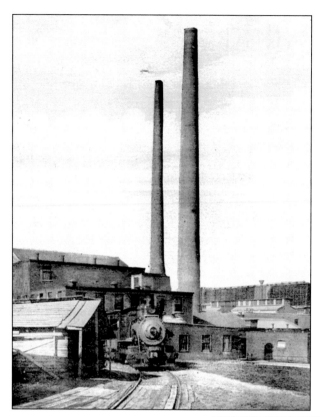

A postcard view of the Kodak plant postmarked 1907 boasts that the stacks were the highest in the world. Of equal interest is the train. Eastman Dry Plate Company, erected at Platt and State Streets in 1882, became a self-contained complex with its own railroad, fire department, power sources, and water system.

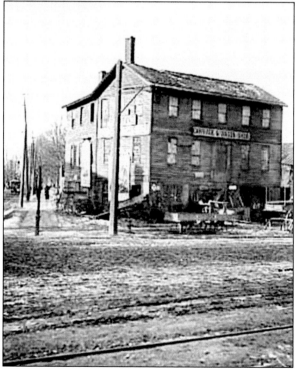

The Frankfort Tavern, shown in 1891, stood on the corner of Lake and Lyell Avenues. Lyell runs along the left side of the structure. At one time the tavern housed the Frankfort Carriage Repository. During the late 1880s it was known as the Bonesteel Tavern. The foundation was made of stone and the upper stories were made of wood. Stagecoach travelers were welcomed here, as were workers from the riverside industries looking for after-work refreshments.

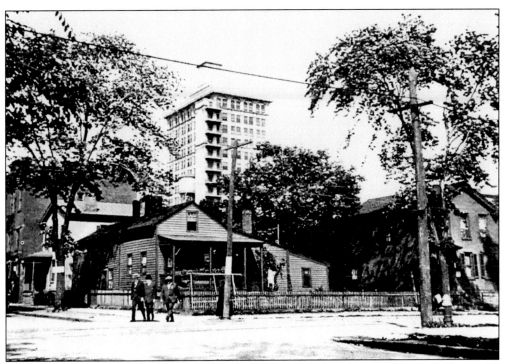

The Kodak tower, headquarters for the Kodak company, looms over the simple homes of Frankfort Street in this c. 1916 image. As Kodak quickly expanded, it bought commercial and residential blocks along State, Platt, Frankfort and other streets near Brown Square. Slowly, residential streets were pushed back from the industrial area. (Courtesy Landmark Society of Western New York.)

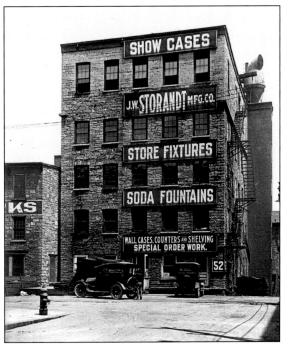

As Kodak, Bausch and Lomb, and the breweries expanded, Brown's Race grew less efficient and was abandoned by industries looking to grow. The introduction of steam and then electrical power allowed factory owners to leave the river area. The coming of the automobile created another problem—limited parking. The J. W. Storandt Manufacturing Company proclaims its product line in this c. 1920 photograph. (Courtesy Irondequoit Chapter D.A.R.)

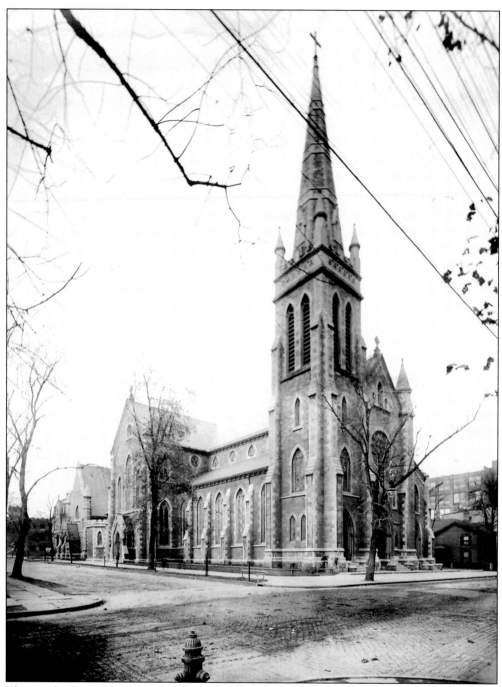

The parish of a sizable Irish colony built the first Catholic church in western New York in 1823 on the corner of Frank and Platt Streets. Several edifices preceded this magnificent structure, Saint Patrick's Cathedral, which opened in 1869. It was not officially consecrated until 1898, when the spire was added. The Diocese of Rochester was organized in 1868. Kodak purchased the property and tore the church down in 1938.

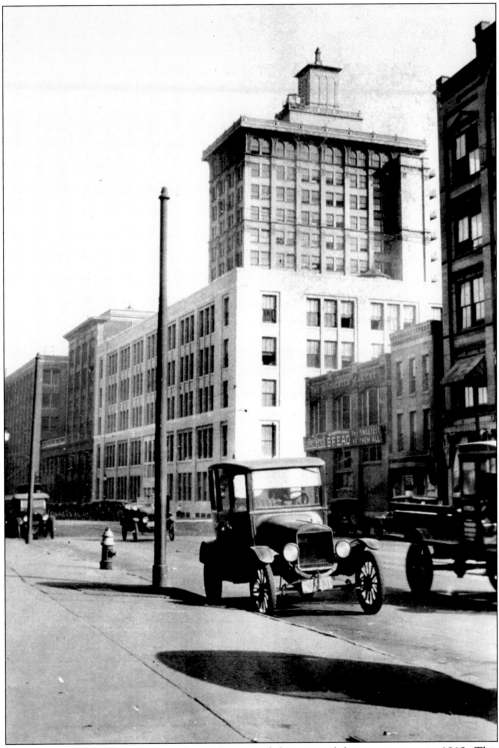

The Kodak Office Tower was built on the site of the original factory starting in 1912. This southwest view looks along State Street. (Courtesy Rochester City Hall Photo Lab.)

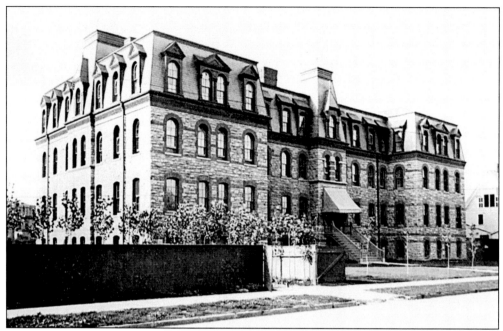

St. Patrick's Girls' Orphan Asylum was located in a lot behind the cathedral. It opened in 1842 and was administered by the Sisters of Charity. A steady influx of Roman Catholics, primarily Irish and German immigrants, strained parochial resources, especially when waves of French, Italian, Lithuanian, Polish, and Ruthenian Catholics began to arrive. The asylum came under the care of the Sisters of St. Joseph in 1870.

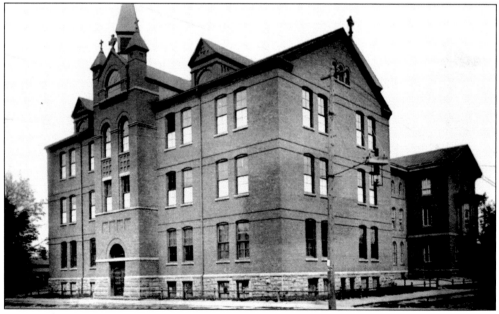

St. Patrick's School was a major part of the cathedral campus at Frank and Brown Streets. The parish school started in 1830 in the basement of the first church. This school was built c. 1871 and was free to children within the parish. It closed c. 1938 and was razed in 1960. There were 2,056 children in the parochial schools of the five German churches in 1868.

Rev. Bernard J. McQuaid was consecrated bishop of
Rochester in St. Patrick's Cathedral in New York
City on July 12, 1868. He took over a poor diocese
of 60 churches. When he died in 1909, his 40-year
episcopate left a prosperous diocese filled with
churches, schools, charities, and seminaries to meet
the needs of approximately 121,000 Catholics.

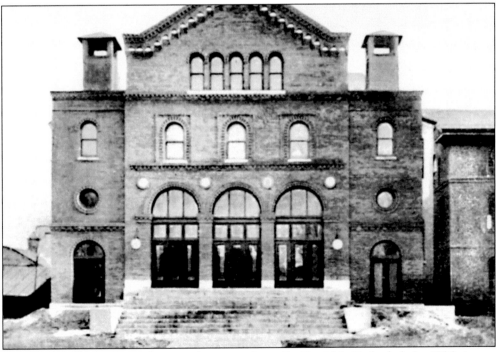

Cathedral Hall was located across the street from St. Patrick's Cathedral. In 1906, it was
converted into a coeducational high school. Bishop McQuaid was determined to establish
high-quality parish schools, and he developed excellent teachers in his own order of the Sisters
of St. Joseph. He strove to provide even the poorest students with an education equal to that of
wealthier children.

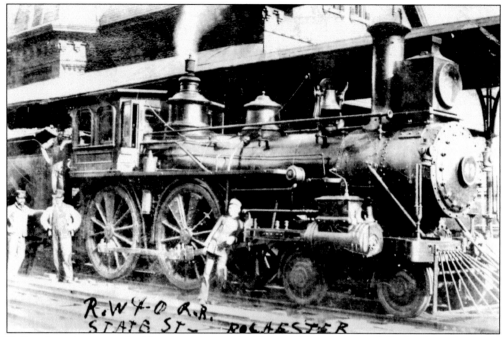

Railroad workers pose beside an engine at the Rome, Watertown, and Ogdensburg depot on State Street in 1905. The depot was located on the west side of the river. (Courtesy Rochester Public Library Local History Division.)

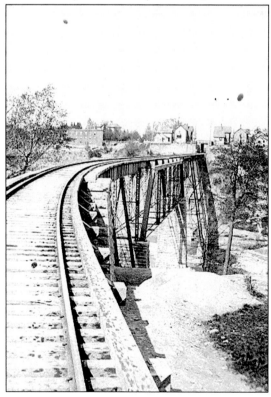

Trains leaving the Rome, Watertown, and Ogdensburg depot on State Street crossed the Genesee gorge via this impressive span. Passengers were provided a spectacular view of the river gorge. This c. 1890 scene is from a stereoview.

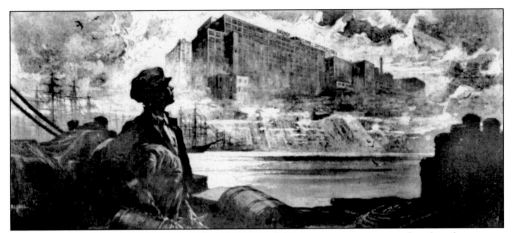

This romantic illustration captures the promise of American opportunity that lured so many immigrants here. The lad shown is John J. Bausch , an apprentice from Suessen, Wuerttemberg, Germany, and he is gazing into the future. The fortress-like walls of the optical company he later developed with partner Henry Lomb soar atop the Genesee gorge. John and Henry started it as a little daguerreotype and eyeglass shop in the front part of a cobbler shop at the Reynolds Arcade in 1853. They grew it into the world's leader in precision optics. Hundreds of Dutchtown residents worked at the factory, making the daily treks across the Bausch and Platt Street bridges.

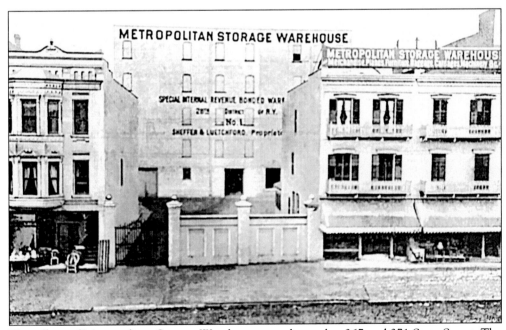

The offices of Metropolitan Storage Warehouse were located at 367 and 371 State Street. The warehouse was in the rear and backed to Frankfort Street. It provided storage and shipment of furniture and pianos, as well as boxing and packing services. The company's advertisement read, "Porterage and everything appertaining to the storage and handling of property."

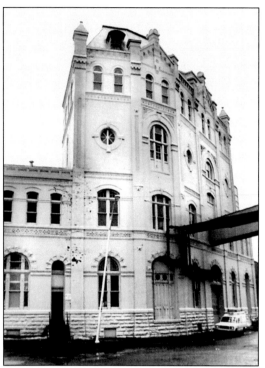

German immigrants brought their brewing skills to the industrial village. Impressive breweries lined the gorge like Rhineland castles. This richly detailed brick structure stands at 13 Cataract Street at the end of Platt Street. It was originally Standard Brewing Company in 1899. In 1956, it merged with Rochester Brewing Company and they became Standard Rochester Brewing Company.

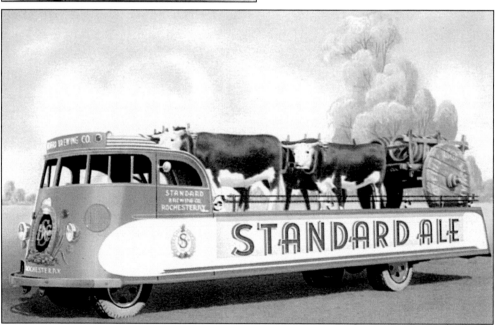

A Standard Brewing Company exhibit shows how oxen were used to deliver ale well over a hundred years ago. The postcard explains that "Rochester's most popular beverage" continued to be made "just as it was nearly half a century ago, from the same formula, and it is properly aged always in rock-hewn cellars deep in the banks of the Genesee River." During Prohibition, the breweries suspended production of beer and converted to dairy products. When the noble failure ended in 1933, production of alcohol-based products resumed.

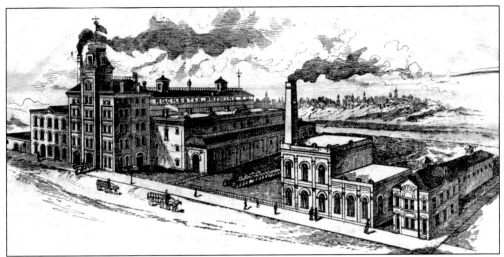

The Rochester Brewing Company on Cliff Street produced beers from 1874 until 1901. The smaller buildings on the right were operated as the E. M. Upton Cold Storage Company from 1903 to 1969. Wagons delivered ice to homes in the neighborhood. Other breweries north of Brown's Race included Catatract Brewing Company, Duffy Malt Whiskey, Bartholomay Brewery, and the American Brewing Company.

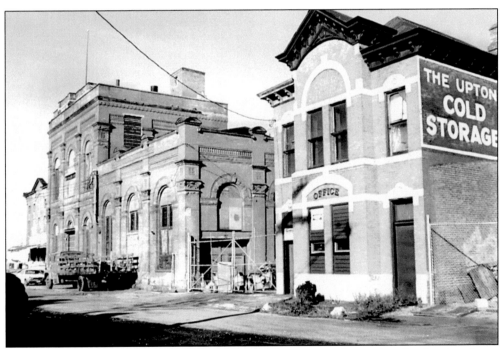

This photograph, taken in 1980, shows the two brick structures depicted in the drawing above. They retain the fanciful details often found in brewery architecture. The local Germans' Bock and Bavarian beers, which they started brewing in the 1870s, were preferred over the lighter English ales. Demand was such that an ice-cutting and storing industry sprang up to keep the beer cold. These buildings used cork for insulation. Additionally, advances in fermentation led to the formation of Pfaudler Vacuum Fermentation Company, manufacturers of glass-lined tanks.

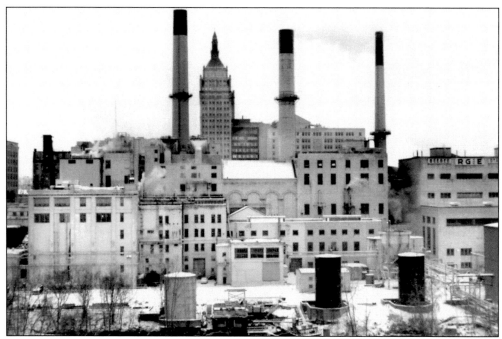

The distinct Kodak Office Tower is visible between the massive stacks of Rochester Gas and Electric's Beebee power station. This coal-fed behemoth, pictured in the early 1980s, shows the extent to which the Brown brothers' little industrial village had grown. The station is no longer in use.

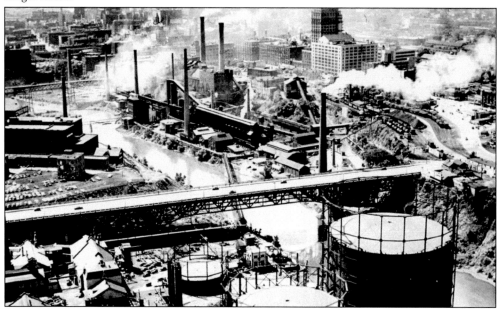

A disturbing c. 1930 image was actually used to promote Rochester's industrial might in order to attract more industry. Rochester Gas and Electric's east and west stations are pictured. They were connected by a footbridge running beneath the Bausch (or Smith Street) Bridge. Other industries are crammed along the gorge floor. In the lower right are enormous gas holding tanks. (Courtesy Rochester City Hall Photo Lab.)

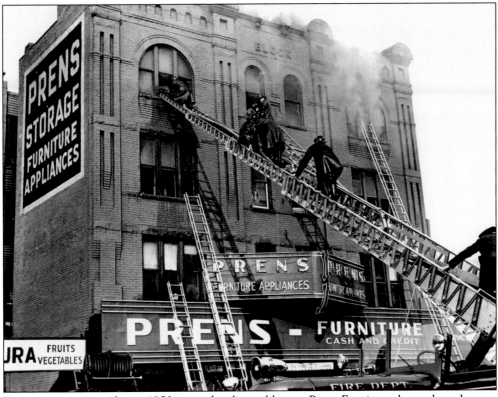

Firemen are seen in this c. 1950 image battling a blaze at Prens Furniture, located on the east side of State Street near Brown's Race. (Courtesy Thomas DellaPorta.)

The mills and factories along Brown's Race became a deteriorating enclave, forgotten and ignored for generations. In the late 1960s, interests stirred when historians pointed out the area's significance, and by 1980 development was underway, including the creation of a water-filled race. The area is considered Rochester's greatest historic and scenic asset, providing visitors with a sense of the city's industrial beginnings. Shown are the falls and remnants of the old milling days. An observation platform over a foundation allows visitors to peer deep into the tomb of an early mill. With Dutchtown having been split by a highway and reworked in places, it is hard to consider this as part of the old neighborhood, but for over 150 years, many Dutchtown residents labored here.

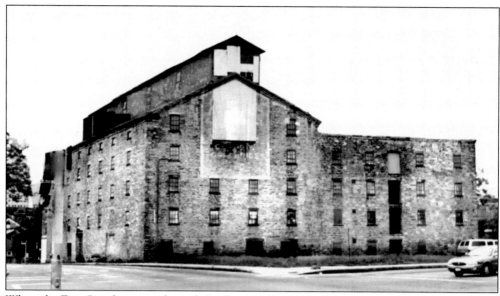

When the Erie Canal was cut through Rochesterville, a row of stone warehouses went up along Warehouse Street. They stored flour and cargo transported by barges. The Parson's Malthouse is the last survivor. It is a dramatic landmark visible from many places in Dutchtown. The site was leased to Matthew Brown Jr. in 1825. The original north end section is five stories high and is built of Medina stone. In 1869, the malt house addition was built. It retains the original malting floors–thick cement floors able to support the hot, heavy iron kilns used to prepare grain for beer. Bartholomay Brewing Company acquired it in 1889.

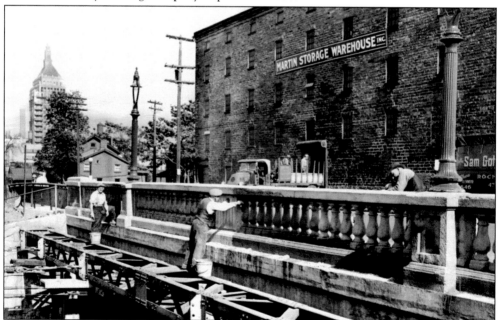

Workers make repairs to the Brown Street Bridge in September 1943. The bridge spans the subway tracks, which were laid in the abandoned Erie Canal bed. Parson's Malthouse is across the street. It was Martin Storage Warehouse in the days when this northeast view was taken. (Courtesy Rochester Municipal Archives.)

This contemporary view of Frankfort Street would hardly turn heads, but it is nonetheless interesting, as it bears little resemblance to the original village. Early homes have been reworked into small businesses. Kodak's tower is in the distance, like a lighthouse in a fog.

This photograph by Thomas DellaPorta reveals the beauty and symmetry of the Kodak tower.

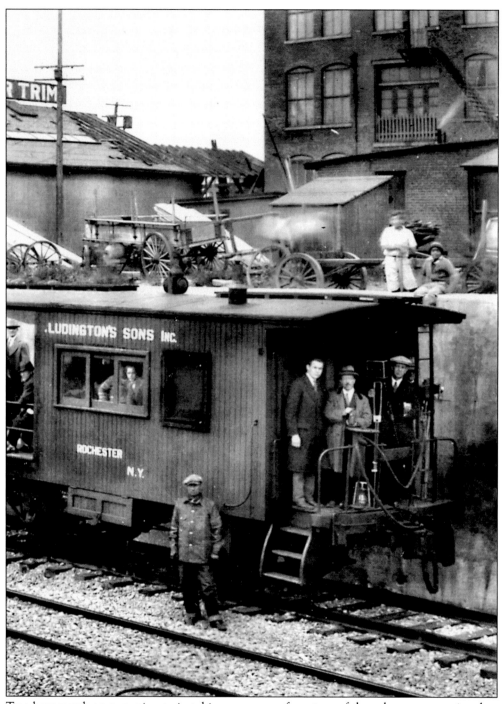

Two boys watch an excursion train taking passengers for a tour of the subway on opening day, November 16, 1920. This is a detail from a photograph taken near Child Street. The boys are in the factory yard of Couch and Beahan Company Interior Trim.

Two

THE OLD NEIGHBORHOOD

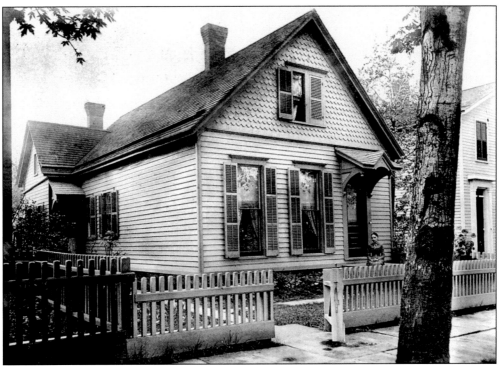

The home of Alvin and Martha Brooks stood on the west side of Frank Street. Their daughter Ardelia was born here. She lived here with her husband, Charles Bruff, until her death in 1918. That is probably her in the yard. In 1933, Howard Kemp wrote of the typical Dutchtown street, "It was paved, if at all, with cobblestones—a row of modest houses lining either side of the street, each enclosed by some sort of an ornamental fence with gay flower gardens in front of the house and a vegetable garden—containing cabbage, principally—in the rear, with perhaps a chicken coop or even a cow or two." (Courtesy Rochester Public Library.)

The c. 1820 North American Hotel, formerly the McCracken Tavern, stood on the northwest corner of State and Brown Streets. It was the stagecoach terminus for the line from Lewiston. Local militias would usually stop here for refreshments after drilling at Brown Square. Neighbors around the square complained that the trees and grass at the square were being ruined by these drills and by baseball. The hotel also served as a political headquarters where caucuses and elections were held during the 1820s.

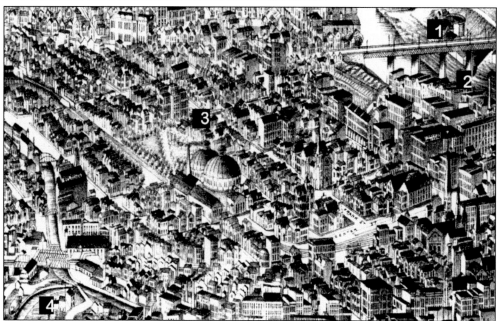

This 1870s bird's-eye view defines the area. At the upper right, number 1 shows the Platt Street Bridge across the river gorge. Just below at number 2 is Brown's Race. Streets running west out of the industrial area enter what was first Frankfort and then Deutschtown. At the center of the picture, number 3 shows Brown Square and the two massive covered roundhouses of the early New York Central Railroad shops. At the lower left, number 4 is where the Erie Canal and Genesee Valley Canal formed a junction at Canal Street. The Erie Canal can be seen entering Deutschtown along what is now Broad Street. The Parson's Malthouse, a large stone warehouse that is still standing, can be seen beside the canal.

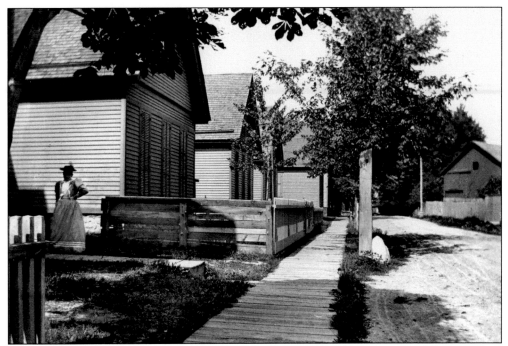

The basic working-class lifestyle of Dutchtown is captured in this 1890s view of Akrow Street. Though small, these homes were the fulfillment of the American dream to thousands of immigrants escaping the poverty of Europe. Homes like these were certainly preferable to the slums of New York City. Note the shuttered windows and the gutters built into the roofs. A single potbelly stove usually heated the entire house—interior gaslights came later. During these days, doctors made house calls, and babies were delivered at home with the aid of a neighborhood midwife. (Courtesy Rochester Public Library.)

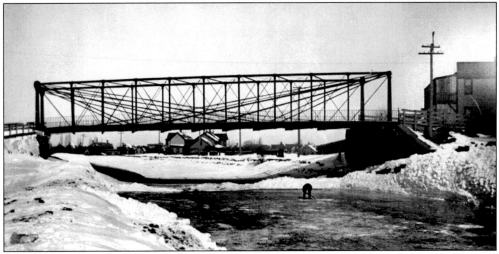

With its many bridges, the canal was a major challenge to the neighborhood. This bridge, photographed in the 1890s, may have been located at Brown Street. It was a truss style with a vertical lift section in the center of the span. In this image, the canal has been drained for the winter. What little water remained usually made for good ice-skating. (Courtesy Rochester Public Library.)

A detail from this stereoview, taken in the 1870s from the roof of the Powers Block, provides a fascinating discovery. Just to the right of the slender church spire are the domes of the two massive roundhouses of the New York Central Brown Street shops. This may be one of the only photographic records of those structures. In the center is an engine house that appears in the top image of page 37. To the far left is a long structure that is either Parson's Malthouse or one of the warehouses near it.

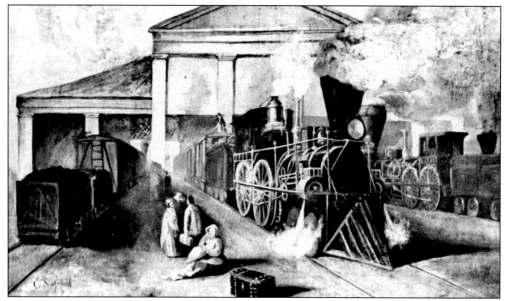

A painting by Eugene Sintzenich shows a train leaving the Auburn station at Mill Street in the 1840s. The Rochester and Auburn Railroad, incorporated in 1836, opened in sections, running to Canandaigua, then Seneca Falls through to Cayuga, and finally reaching Auburn in 1841. The Tonawanda Railroad opened in 1832 and passed through the early neighborhood to a station on Buffalo Street (West Main Street). It passed over the Erie Canal near Canal Street through a beautiful wooden covered bridge. Most of these railroads were eventually assimilated into the New York Central.

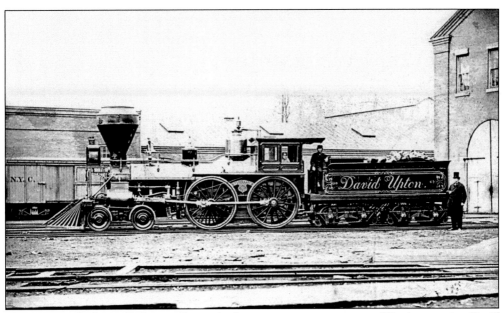

The New York Central's Brown Street facilities were quite extensive. The locomotive *David Upton*, built *c.* 1870, was a fine example of the handsome engines manufactured there starting in the 1860s.

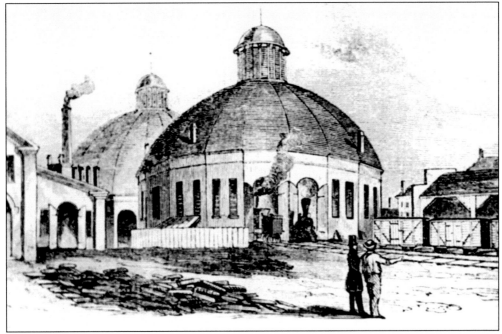

These covered roundhouses are shown in the top photograph on page 36. To the left is the engine house where the locomotive *David Upton* seen in the image at the top of the page was photographed. This site is just about where Frontier Field now stands. The mills, railroads, breweries, and canals all packed together like apples in a sack make it easy to see why the Brown brothers' early industrial village became less appealing as a place to build a home. Residential streets gradually moved west and north.

The intersection of Jay and Child Streets was a German-speaking section in the 1870s. It was called Basket Town because of the basket weavers who sold their products in carts and in local shops. Whether engaged in delicate basket weaving, grinding lenses, or building oak-lined cellars in the gorge bedrock to age beer, the Germans were highly industrious. (Courtesy Rochester Public Library.)

Children stand on the Jay Street Bridge over the canal in 1902. Jay Street is often thought of as the heart of Dutchtown. The German colony here, established by pioneers and augmented by immigrants, was comprised of various religious groups bound to Old Country differences. However, their common language unified them, and they established social institutions and a political voice in city affairs. Jay Street was a hive of social activity with its church festivals, concerts, beerabend festivities, and market gossip. (Courtesy Rochester Public Library.)

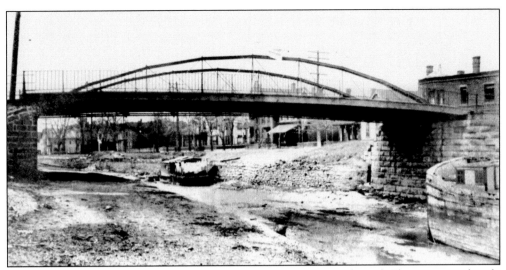

This image of the Jay Street Bridge in March 1902 shows the drained canal. The cast-iron whipple arched bridge dates to the 1860s. A canal boat is sitting in the canal bed with a ramp lying on the bank. Many family-owned boats remained in the drained bed with the families living on them during the winter. There is laundry hanging in the background. These boats had sleeping bunks and were equipped with stoves for cooking and heat. (Courtesy Rochester Public Library.)

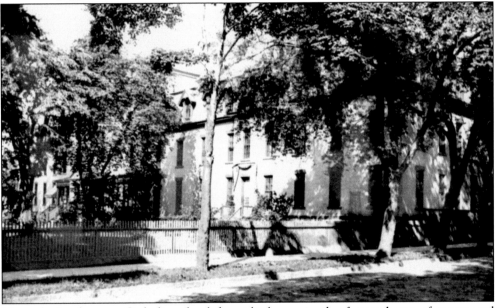

Nazareth Academy, a Catholic school for girls, began in the former home of mayor and congressman John Williams. It was located on the northwest corner of Frank and Jay Streets. Administered by the Sisters of St. Joseph starting in 1871, the academy was also used as the mother house for the sisters. The Sisters of St. Joseph was formed by Jean Pierre Medaille, S. J., in 1650 as a religious community in LePuy, France. In 1836, some of the sisters came to America. An order came to Rochester after the diocese was formed in 1868, and Bishop McQuaid quickly put the sisters to work as teachers. Before governmental services, churches took care of the needy. Rochester—and particularly Dutchtown—had its share of poverty, and the sisters were kept busy staffing schools, hospitals, and orphanages. (Courtesy Rochester Public Library.)

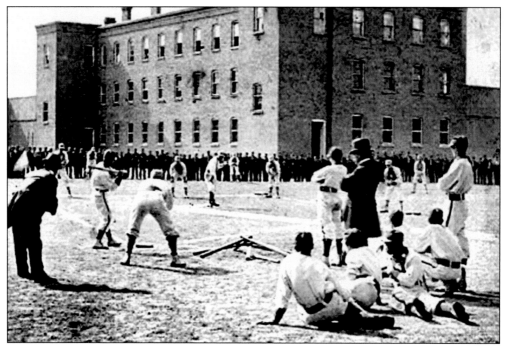

Baseball was a passion that transcended all ethnic squabbling. "Forget this Melting Pot baloney!" a senior Dutchtown resident remarked. "The Italians didn't want to be Germans anymore than the Irish wanted to be Italians! It was baseball that got us together." Any open space or sandlot would do. This game was played on the grounds of the Western House of Refuge in the 1880s. Many saloons, factories, and social groups sponsored teams. To become a team coach was a high honor.

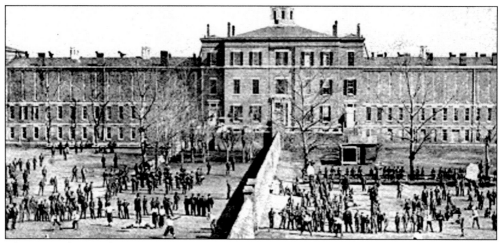

The grounds at the Western House of Refuge were opened to neighborhood and semi-professional teams. This stereoview dates to the 1880s. Howard Kemp, writing in 1933 about Dutchtown's baseball heritage, pointed out, "such Big Leaguers as 'Stump' Weidman, Vic Schhtzer, and Henry Groh, often called the 'Pride of Dutchtown,' got their start in the national game." Others included renowned umpire Bill Klem, "The Old Arbiter," who apparently boasted about his calls, "I never missed one in my life!" "Silk" O'Loughlin was another noted umpire. George Morgridge was a great mounds man, and Ray Gordonier became a celebrated pitcher.

Baseball was forbidden on Sundays during the old blue-law days, but that did not stop boys from gathering at local lots with their gear. There was a favorite diamond located along the railroad wye at Hague Street, and as soon as the crack of a bat hitting a ball disturbed a Sunday morning's peace, word would be sent to the Lyell Avenue Police Station. Deputy Chief Michael Zimmerman was often called to remove the boys. When they saw him coming, they would gather up their equipment and run across the Falls Road tracks into Gates to give him what was called the Bronx cheer.

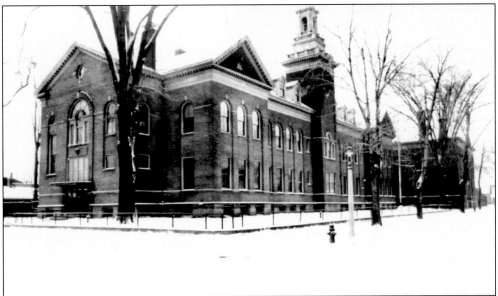

Whitney School No. 17 was built in 1894 on Orange Street, replacing an earlier c. 1858 school. When this photograph was taken in 1935, Italians were supplanting the German population in the district. There was a corner dry-goods store the kids called Peppanut's, and it had the best candy. "You would stop there on the way to school, then on the way home for lunch, and then after school," a resident remembered fondly. (Courtesy Rochester Public Library.)

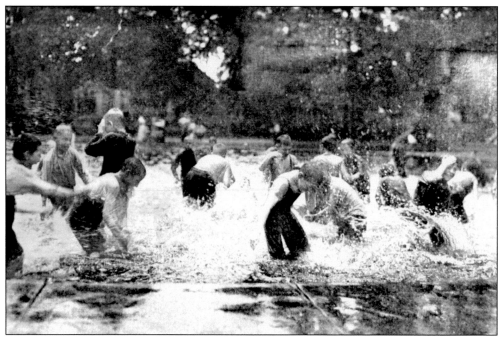

In this 1911 photograph, children cool off in the Brown Square wading pool, built in 1905. It was 100 feet in diameter and was lined with white sand. Brown Square was an important part of the neighborhood, dating back to the old Frankfort days of 1815. Local militia drilled there, and it was a popular baseball diamond. The Germans had concerts and festivals here. Beerabend festivities, where Krause's German Band tooted "Ach du Lieber Augustine," made Saturday nights lively. (Courtesy Rochester Public Library.)

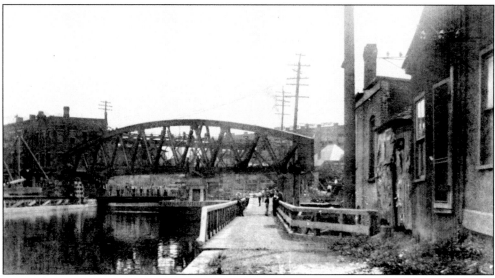

The canal took on a foulness as it passed through the city. In this 1902 image, the canal is approaching the number five vertical lift bridge at West Avenue (West Main Street). Small businesses and homes backed to it. At nearby Magne Street stood dilapidated tenement houses where the poorest families lived. The canal was always a convenient dump, and toward the end it was ripe with odors of oil and diesel fuel. (Courtesy Rochester Public Library.)

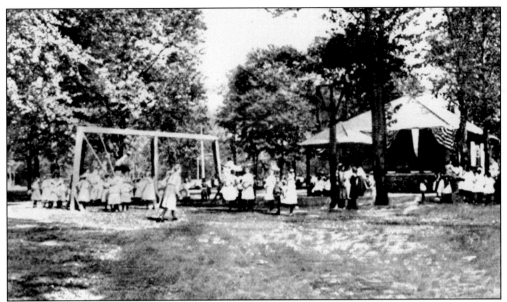

Children are enjoying Brown Square Playground, the city's first. This is opening day in 1903. The park was used for neighborhood picnics and for Festival of the Saints celebrations. (Courtesy Rochester Public Library.)

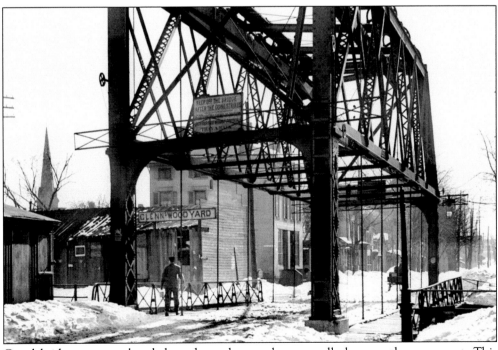

Canal bridges were replaced throughout the canal era, usually because they wore out. This photograph, looking east on Brown Street, was taken March 8, 1900. (Courtesy Rochester Municipal Archives.)

The home of John William, former mayor and congressman, was used as Nazareth Academy, a Catholic school for girls, from 1871 until 1916, when it moved to Lake Avenue. The house, located on Jay Street, was also used by the Sisters of St. Joseph as a mother house. (Courtesy Rochester Public Library.)

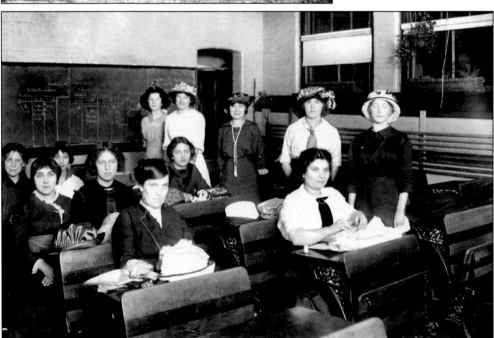

To help immigrant women and men learn English and usable skills, some city schools were opened for evening classes. These young women are learning to make hats. The photograph was taken at the beginning of the 20th century. Churches and settlement houses also taught English to immigrants. (Courtesy Rochester Public Library.)

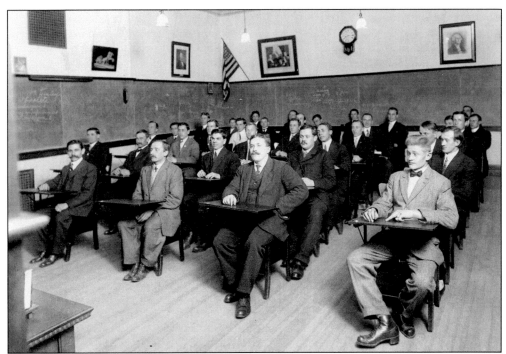

A group of men are enrolled in a night class at a city school *c.* 1901. They were taught English as well as citizenship, cooking, and mechanical skills. The German community was, at one time, concentrated in three areas: Swillburg, Dutchtown, and Butter Bowl. Many of the Catholic population emigrated from Bavaria, Austria, or the former Austro-Hungarian lands along the Danube. They held mass in German until shortly after the beginning of the 20th century. There was also a German-language newspaper, *Der Abendpost,* which lasted into the 1970s. (Courtesy Rochester Public Library.)

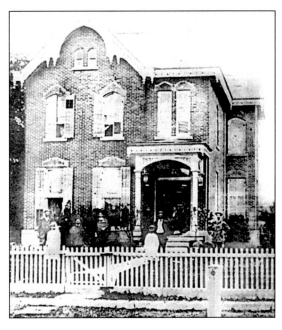

One of the earliest views of Dutchtown is this *c.* 1880 view of the Vay homestead on Maple Street. It still stands, having been incorporated into a small industry. The family was active in their community. There was even a semiprofessional football team, the Dutchtown Vays, that had regular showdowns with teams from the Edgerton neighborhood.

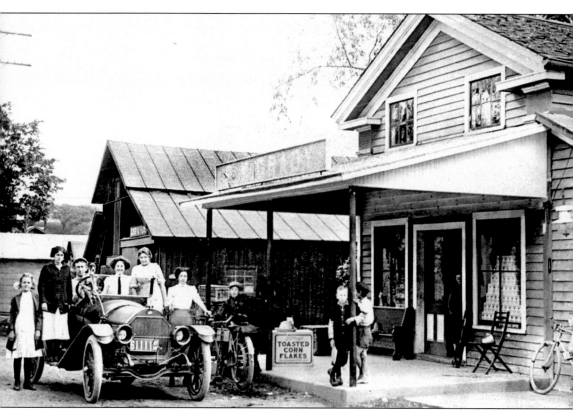

Happy young folk look ready for a day's outing in an Overland automobile c. 1913. Next to the car is an early motorbike. The idle boys seem restless. Hopefully they could go home to secure families. "There were so many orphaned children," a Dutchtown resident said, looking at the photograph. "Young women who had babies by mistake would bring them to the church. They would leave the baby in a basket and ring a special bell. The nuns would come get it. That was not just Dutchtown–that was all over the city. Orphanages were stuffed. For food, young men would kill a horse and bring it into a basement, where they would prepare it. Mothers would come to their door: '*Me dare sei bistecche*, (I'll take six steaks).'" The grocery store was on Jefferson Avenue, probably where it approached Brown Street. (Courtesy Rochester Public Library.)

The Genesee Fruit Company was in business from 1891 to c. 1909. It was located on Moore Street and was known for its apple cider and apple vinegar. This photograph dates to 1895. (Courtesy Rochester Public Library.)

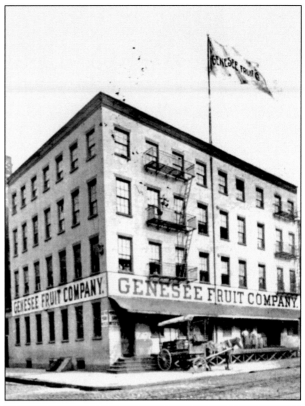

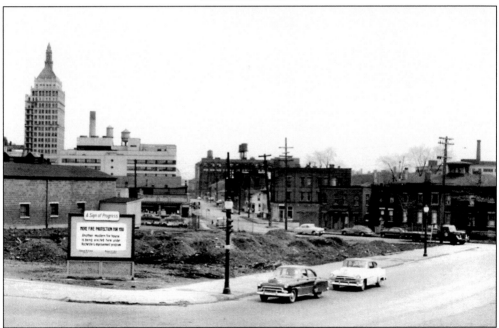

Old buildings at the corner of Allen and Broad Streets were razed in the early 1950s to make way for the construction of a new firehouse. The I-490 expressway now runs along this section. (Courtesy Rochester Municipal Archives.)

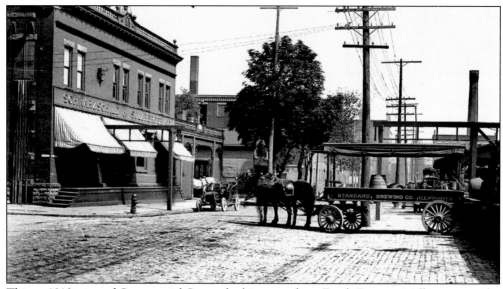

This *c.* 1910 view of Commercial Street, looking east from Frank Street, vividly captures the daily activities of the neighborhood. A Standard Brewing Company wagon is backed to a loading platform along the New York Central tracks. Across the street is Schwarzchild and Sulzberger Provisions Company. (Courtesy Rochester Municipal Archives.)

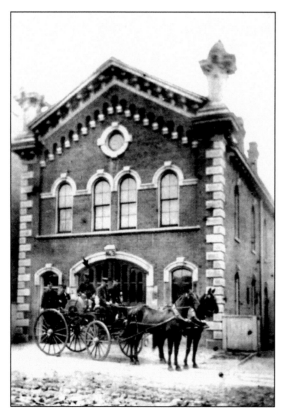

Firemen of Hose Company No. 3 pose with their hose cart in front of the firehouse built in 1869 on Platt Street (near State Street). Kodak purchased the property in 1912. Dutchtown residents west of here clamored for a firehouse, particularly in the Jay Street area. When a fire broke out, equipment from other districts often had to come across the railroad, which slowed things down if a train was passing. The same happened if firefighters encountered raised canal bridges. The Gerling family, longtime Dutchtown advocates, got Jacob Gerling Jr., then on the board of aldermen representing the 20th ward, to convince Mayor Edgerton to approve a firehouse. It was built on Child Street. (Courtesy Rochester Public Library.)

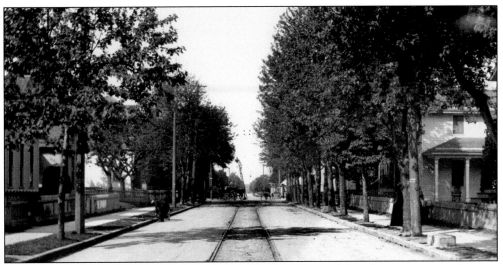

Jay Street in September 1900 appears peaceful and well maintained. Dutchtown was never fancy or pretentious, although it contains many architectural styles. There is a single trolley track running down the center of the street. The view is from Immel Place looking towards the intersection with Ames Street. A resident recalled, "We would hear the trolley all night, especially when it was hot and we had our bedroom windows open. When it rained there was this 'electric' smell in the air when the trolleys passed." (Courtesy Rochester Municipal Archives.)

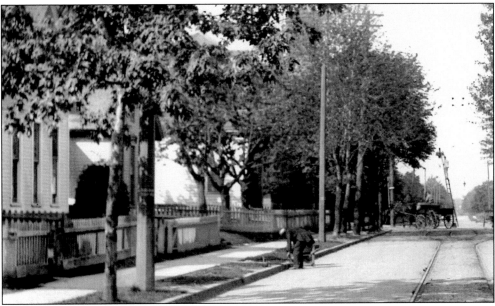

A detail from the previous photograph shows a workman on a ladder repairing a streetlight in the intersection of Jay and Ames Streets. An Italian-American resident remembered growing up around here. "It was stressful sometimes because they did not want the Italians moving in. We had to keep our property perfect and our parents told us never to answer back if someone said mean things to us. Some of the old Italians scared us kids. They were superstitious, keeping garlic over doorways to chase evil spirits away. They would waggle their fingers beside their faces and put the evil eye on you, a kind of curse!"

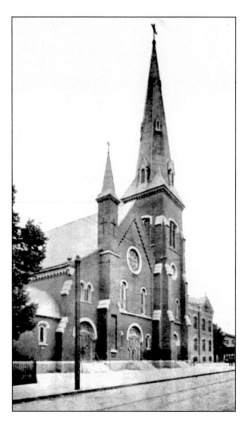

The Holy Family Church and campus, pictured in the 1880s, has dominated the corner of Ames and Jay Streets since 1864. The German Catholic parish built the church to handle the people that SS. Peter and Paul's could no longer accommodate. This larger church was blessed by Bishop McQuaid in August 1868. Stained-glass windows were installed c. 1902, and magnificent stations of the cross were imported from Europe for $2,200. The steeple was replaced during the Great Depression due to deterioration, and a simpler one was built.

This view of the Holy Family Church's pastor's residence dates to 1888. By 1893, the parish accommodated 830 families, and over 1,000 children attended the school. The masses were held in German until 1900, when children, growing less familiar with the language, requested a change to an English sermon, at least for them. Holy Family priests, Sisters of Notre Dame, Sisters of Mercy, and Sisters of St. Joseph addressed many of the charitable, religious, and educational requirements of immigrant parishioners and also served as missionaries around the world.

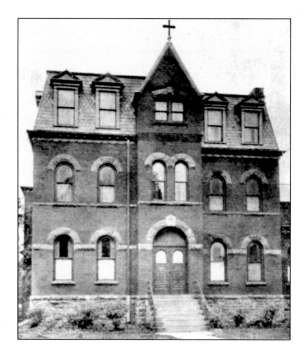

Children sit on a curb and carriage block on Jay Street with the Holy Family School looming behind them. The first school, a frame building north of the church, was built in 1871. Father Hofschneider, who was utterly devoted to his parish, had this one built in 1881. It was torn down for a campus parking lot. The current school was built in 1930. There was also a four-acre cemetery located on Maple Street. In 1955, vandalism resulted in the relocating of over 900 bodies to a lot at Holy Sepulchre Cemetery.

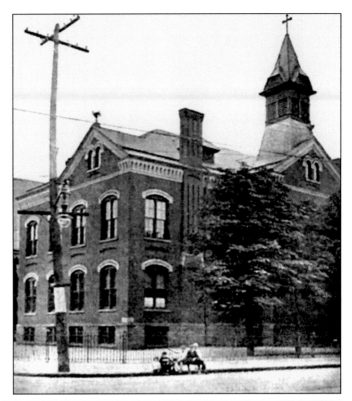

Holy Family Church and campus remains one of Dutchtown's most beautiful features, as seen in this contemporary view. Though it was once decidedly German, by 1964 most of the Germans were gone, having moved to Gates or "Little Dutchtown." Half of the parish was Italian, and there were some Polish and Ukrainian families. Hispanics and African Americans gradually moved in. The church and school continue to thrive today.

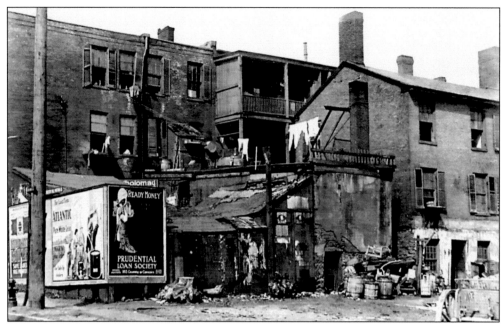

The deterioration of the commercial end of Brown Street is evident in this c. 1915 photograph. The building on the right was probably built in the 1820s, when the Brown brothers were developing their district. Low-rent apartments housed the city's poorest families. As the mill district deteriorated into shabby skid rows, nearby Industrial Street became a red-light district with its own colorful madam, Lib Goodrich, who openly invited men to consort with her boarding girls. When the police shut down her "resort" in 1913, they found a cellar of illegal liquor in addition to the prostitutes. (Courtesy Rochester Public Library.)

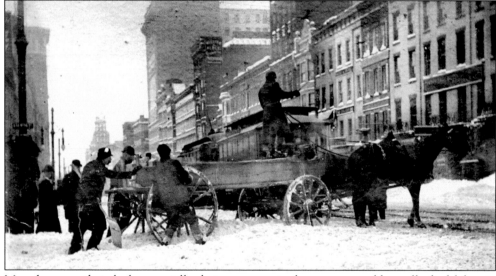

Men down on their luck, especially during economic downturns, could usually find labor in the city. Canallers in particular were hard-pressed during the winter months when the canal was closed. Some found work at the city rock pile, where they crushed stone for street paving. City maintenance shifts provided seasonal labor. In this Depression-era city view, a work gang removes snow on East Main Street. (Courtesy Rochester Public Library.)

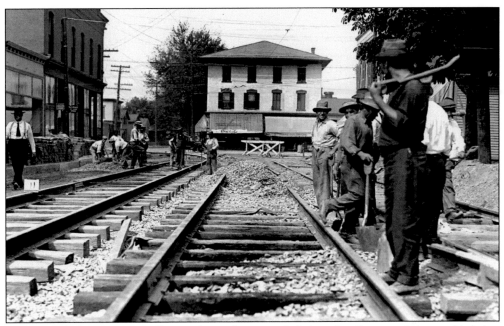

In this *c.* 1910 view, new trolley tracks are being graded along Jay Street and the road is being paved with bricks. Metzger Brothers Grocery Store is in the building straight ahead at the intersection of Child Street. John Priesecker, known as "Frog Leg" George, would sell frogs for their legs from his peddlers cart as he passed through the intersection on the way to his stand on Front Street. He lived in the area with a smelly menagerie of swine, geese, and other livestock. When children gathered by his cart, he would sometimes devour a live frog and send them off squealing. (Courtesy Rochester Municipal Archives.)

Rochester's Italian population increased twentyfold between 1891 and 1920. Most were Roman Catholics, but there were a few Protestants in the bunch. The Waldensians, a congregation with Protestant ties founded during a dispute with the medieval church, settled in the area of Jay and Smith Streets. They held street-corner services with Salvation Army zeal and were sometimes pelted with stones. Noted architect Claude Bragdon designed their church, which opened in 1915 at 766 Broad Street. This 1967 photograph of the Italian Presbyterian Church, taken by George Lodder, shows it shortly before it was converted to a Pentecostal church.

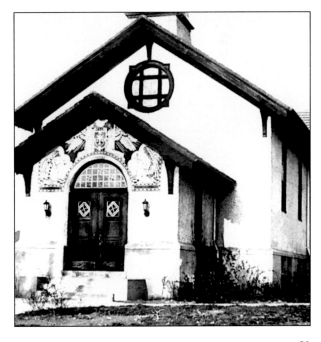

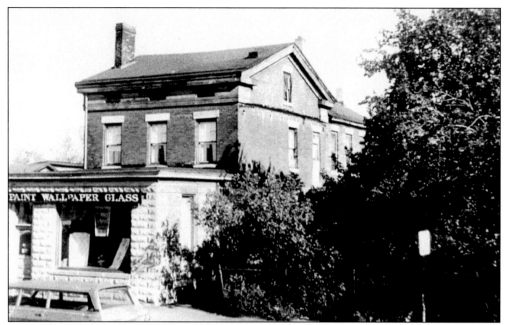

A sturdy brick residence on Oak Street had all the elements of a classic Greek Revival building: stone lintels and sills, entablature, and eyebrow windows. It was adapted to commercial use c. 1900 with a cast stone block addition. Neighbors could purchase paint, wallpaper, glass, and other supplies from the store. The Erie Canal, and then the subway, ran across the street. The impressive stone warehouse on Brown Street loomed not far away. This photograph was taken in the early 1970s, when urban renewal prompted the Landmark Society of Western New York to photograph threatened areas.

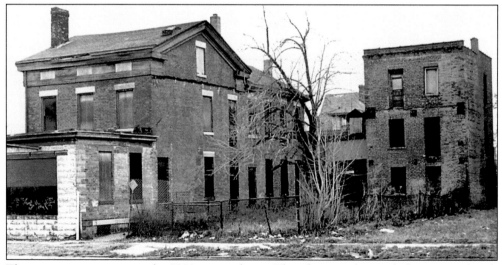

The same property, seen in the 1980s, is a sad ruin. This photograph reveals fascinating details of a small commercial site. The paint store is gone, but an intriguing little brick warehouse is to the right. Note the loading doors and the indications on the brick façade of porches and roofs over the loading platform. One can imagine small wagons entering the fenced-in yard with goods to be stored in the warehouse. It must have been quite a time, with brawling canallers, carts being trundled from loading docks, and trains chuffing in the nearby Brown Street yards.

A brick commercial building at 396 Oak Street was another example of a residence being enlarged and modified to accommodate businesses and apartments. There are stone lintels above the rear windows and decorative arches over the front ones. What was likely a storefront with large windows was bricked in. This building was photographed in 1968 by volunteers of the Landmark Society of Western New York.

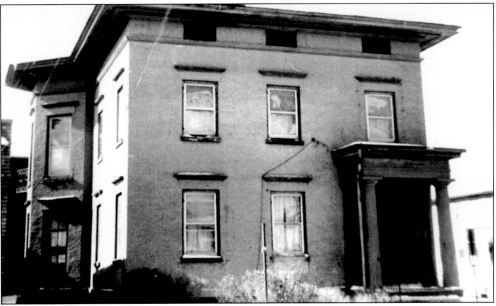

A substantial Italianate building on Oak Street faced limited sunrises when this photograph was taken in the early 1970s. Where Oak Street approached West Main Street, there once was an Irish colony called Fiddler's Green. Later it became the canal zone. Where Oak Street curved under the New York Central tracks was a literal red-light district. Railroad men came from the tracks at night and passed through the yards of houses used as "resorts." The men would hang their lit railroad lanterns, which had red globes, on fence posts before going inside. (Courtesy Landmark Society of Western New York.)

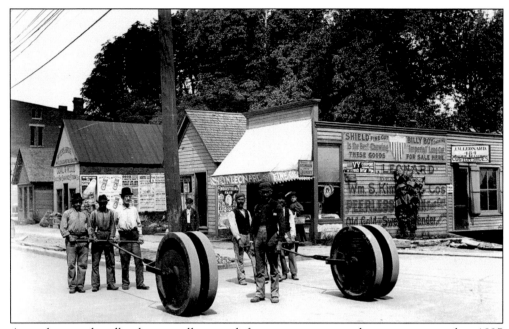

A work gang handles heavy rollers used for compressing road pavements in this 1897 photograph of State Street, taken slightly south of Lyell Avenue. The buildings behind them are heavily illustrated with advertisements. There is a coal and wood business and several mom-and-pop stores selling, among other products, cigars and shoes. (Courtesy Rochester Municipal Archives.)

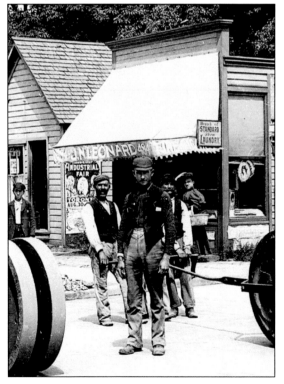

A detail from the above image shows a rough-and-ready crew. By this time, German predominance in Dutchtown was fading and was being supplanted by waves of Italian immigrants. They were mostly peasants, like the Irish before them, and were given only the worst jobs. Those jobs included sewer and road work, which often meant living in labor gang camps. Many immigrants were brought to America by a padrone (boss or master). In some ways, it was little more than a feudal apprenticeship. Gradually, Italians achieved equal recognition, both socially and politically.

Three

ALONG THE SOUTHWEST BORDER

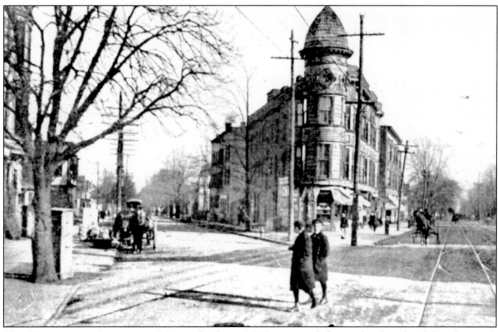

The Kensington Apartment House, built *c.* 1900, was a defining landmark of Dutchtown's southwest border for generations. Situated at the intersection of Brown Street and West Avenue (West Main Street), it also housed a barbershop, a drugstore, and several other businesses. The area is known as Bull's Head after an early tavern. In the late 1820s, investors developed a large cattle mart in the area. Matthew Brown wasted no time hacking a road from his industrial village to the busy road to Buffalo. The road veering to the left was originally Court Street and then became Brown Street. It was noted for its fine homes.

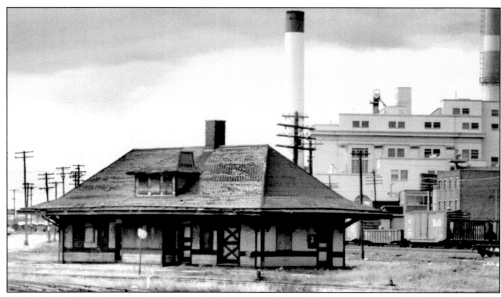

The Buffalo, Rochester, and Pittsburgh depot stood near the intersection of West and Lincoln Avenues. In the distance is the Rochester Gas and Electric power station. In the immediate area were New York Central car shops, Kodak's Lincoln Park plant, and a slaughterhouse that, when the wind was from the north, filled the neighborhood with a terrible stench. Frank Lombardo, who worked nearby at Symingtons, had memories of the slaughterhouse. "After killing the cattle, they would hoist them and wash their guts down a sluice. Mothers would send their sons with a bucket. For 25 cents they would fill it with innards and bones for cooking. There were always dogs around that place."

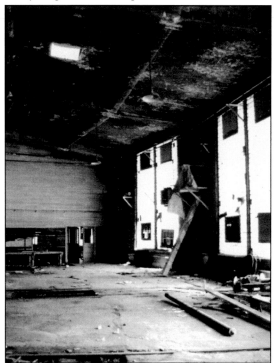

In 1882, the Buffalo, Rochester, and Pittsburgh Railroad built a 14-stall roundhouse at its Lincoln Park facilities along West Avenue. This interior view was taken in the 1970s. In the 1990s, the building was converted to a warehouse, and it remains Rochester's last surviving roundhouse. Many neighbors worked for the railroad. An engineer on Garfield Street would let his wife know he was about half an hour away with three blasts of his engine's whistle. His wife knew it was time to get dinner ready.

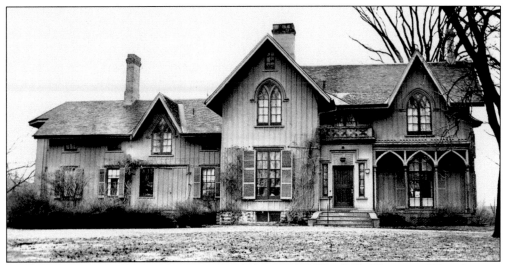

Famed architect Claude Bragdon considered the c. 1840 Danforth House on West Avenue one of the most interesting homes of its time. It was built for Judge George F. Danforth, and the social elite of Corn Hill would come out to the country for visits here. In 1949, daughter-in-law Mrs. Henry G. Danforth gave the house to the city. It was converted to the Danforth Recreational Center, a facility for senior citizens. (Courtesy Rochester Public Library.)

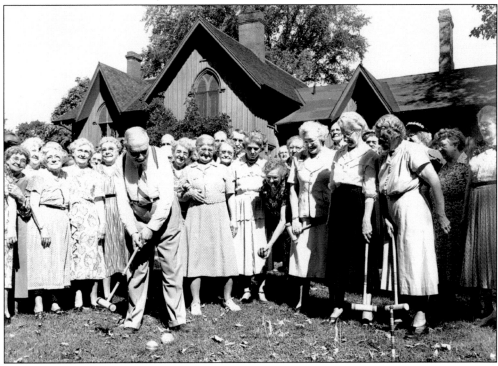

Seniors play croquet at the Danforth Recreational Center. The home, situated on four acres, had 17 rooms. The center opened in 1954 and offered seniors outdoor activities, such as picnics and horseshoes. It is the only remaining home on the north side of West Avenue, which was lined with elegant mansions. The railroad separated West Avenue from the rest of Dutchtown. (Courtesy Rochester Municipal Archives.)

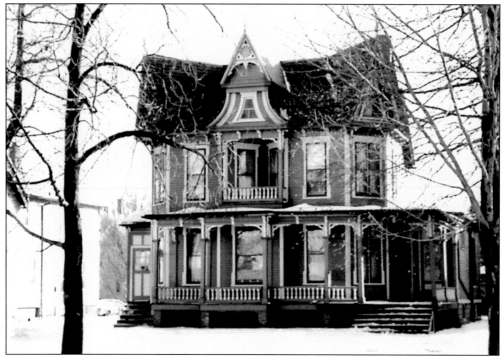

West Avenue is a special place, having retained a quiet dignity in a way that few Rochester avenues have. Most of the homes on the north side were razed for factories, but those industries were set back with expansive lawns and were always well maintained to the point of giving the avenue a park-like feeling. This beautiful side-by-side, shown in the 1980s, has a unique appeal. Being on the south side, it is actually in the 11th ward. Its fanciful painting was done when the "painted lady" craze was the trend.

This 1952 view up West Avenue was taken across the street from the Danforth House. Although the avenue was never as magnificent as East Avenue, it was certainly impressive. It has a Claude Bragdon–designed house, and George Eastman lived on the avenue. Slightly west of the Danforth House was Taylor Instrument. (Courtesy Rochester Municipal Archives.)

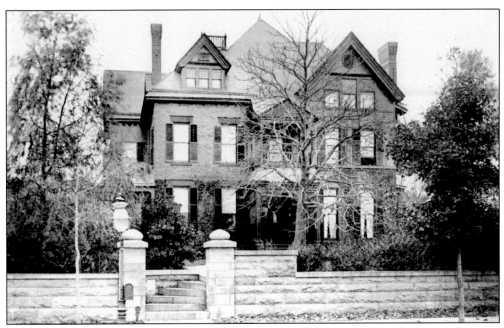

The Alfred Wright residence stood at 333 West Avenue. Wright ran a perfume-manufacturing business from a factory at West Avenue and Willowbank. His products were sold nationwide. He was active on the boards of banks and other local companies. (Courtesy Rochester Public Library.)

Doctor Frederick Remington resided at 275 West Avenue with his wife, Eva. He was born in 1866. In 1888, he graduated from Harvard, and in 1889 he began a private practice. Later he became secretary of the Monroe County Medical Society. For one year he was an intern at the Rochester City Hospital.

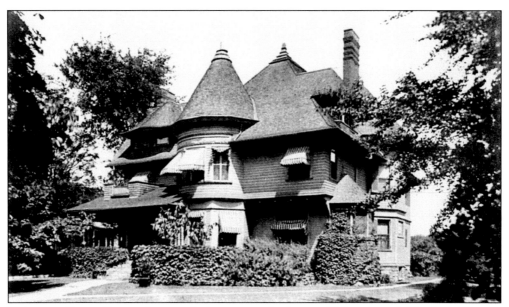

This magnificent Queen Anne–style house was the home of Horatio and Charlotte Graves. It was one of two surviving homes on the north side of West Avenue until it was moved in the early 1980s. Horatio ran a highly successful furniture store that originally utilized three old buildings on the corner of Mill and State Streets. It was one of the largest stores of its kind between New York City and Chicago, selling everything from stoves to carpets to crockery.

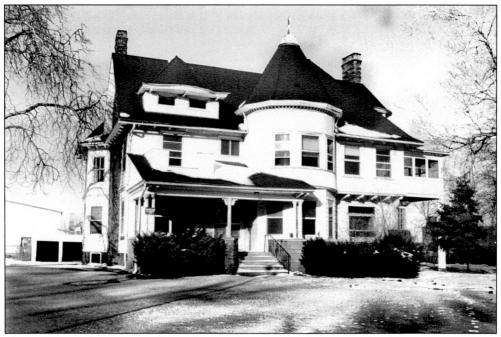

The Graves residence was used for offices, and many consider it a wonder that it survived, since one of the avenue's largest factories was built directly behind it. It is pictured here in the late 1970s, sheathed in aluminum siding. At the time, there was a controversy stirring as to whether it should be demolished.

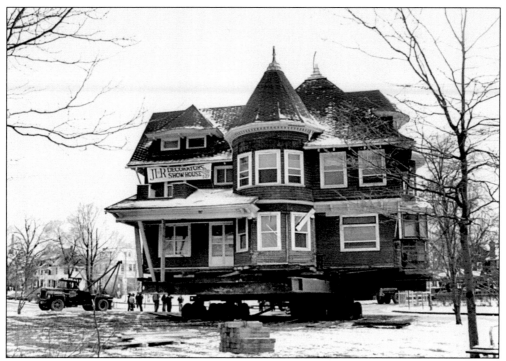

The preservationists won the battle, and on a snowy weekend in the early 1980s, the house was transported across Taylor Instrument's parking lot and then across the lawn of the Danforth Recreation Center. It was moved across the street to its new foundation, and every stone of its front porch, each having been numbered, was skillfully replaced. The project was undertaken as a Junior League of Rochester decorator's show house.

The Lester family residence, now gone, stood on the north side of West Avenue. It was a beautiful Tudor with lush grounds. Technicians brought from Germany to work at Taylor Instrument and Ritter-Pfaudler owned some of these fine homes.

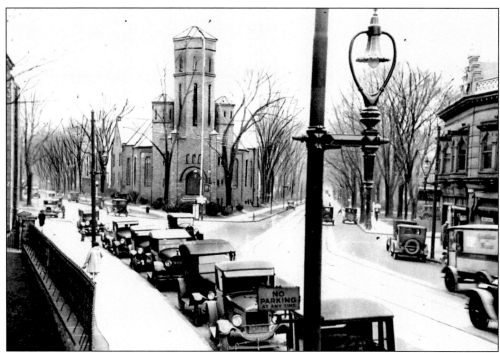

A view of Bull's Head in 1928 shows West Main Street dividing at the West Avenue Methodist Episcopal Church. Chili Avenue is on the left, and West Avenue is on the right.

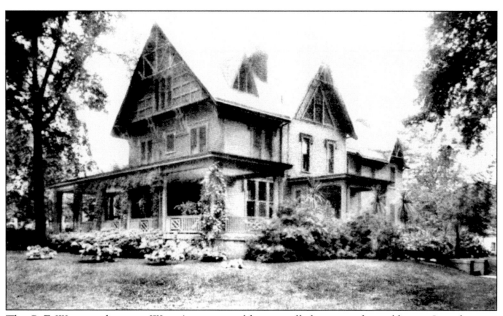

The C. F. Wray residence on West Avenue would eventually became a funeral home. It underwent extensive remodeling in the 1970s and has since been operated as Corbett Funeral Home.

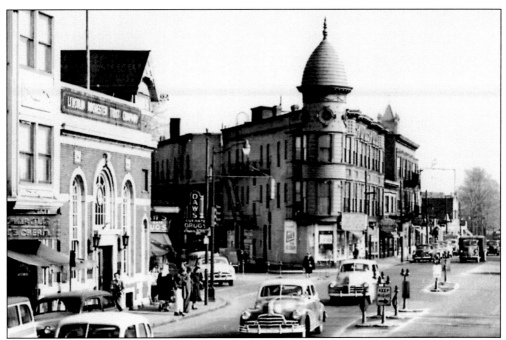

Another look at the c. 1900 Kensington Apartment House in 1950 shows a thriving commercial area that soon declined due to the problems that affected many other urban sections. This distinct landmark, poised between Brown and West Main Streets, was balanced with the West Avenue Methodist Episcopal Church (pictured on page 64) just west of it. The church was Romanesque and the apartment was Queen Anne, but they were almost mirror images of each other. (Courtesy Rochester Municipal Archives.)

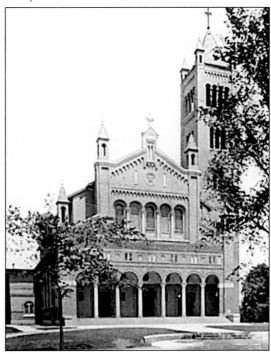

The magnificent SS. Peter and Paul Church on West Main Street was built by the German Catholic community. They originally worshiped at the church of the same name on the corner of Maple and King Streets.

65

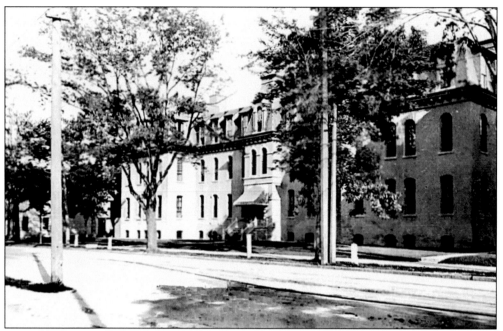

St. Mary's Boys' Orphan Asylum was established in 1864 under the care of the Sisters of St. Joseph. Located on the corner of Buffalo Street (West Main Street) and Genesee Street, it was built on the site of the original Bull's Head Tavern. In the 1960s, Bull's Head Plaza was built here.

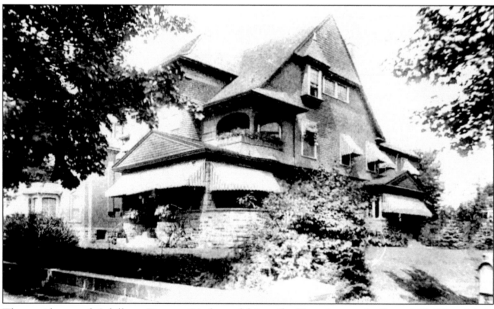

The residence of Adelbert Pierson Little and his wife, Francis, was built at 342 West Main Street on the corner of Wentworth Street. Adelbert, born in 1843, was a stenographer for the Supreme Court for 21 years after his graduation from the University of Rochester. He became successful in manufacturing typewriter supplies, a business he started in 1885.

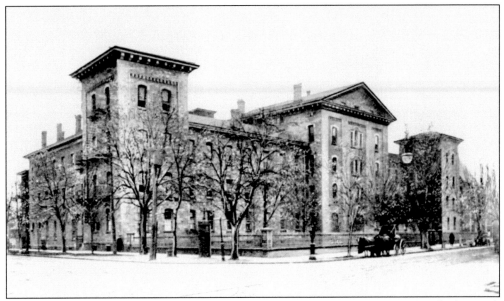

St. Mary's Hospital at Bull's Head was organized by the Sisters of Charity in 1857. The hospital, shown here in a postcard dated 1906, was built during the Civil War on the site of an old country cemetery.

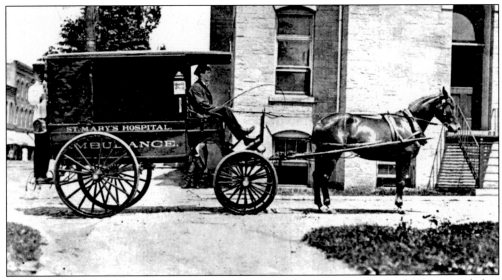

St. Mary's Hospital began ambulance service in 1864, bringing mainly Civil War wounded to the hospital from the railroad depots. This ambulance, photographed beside the hospital in the mid 1890s, is equipped with lanterns, and it has been pointed out that it had rubber tires. The driver and attending surgeon wore uniforms. (Courtesy Rochester Public Library.)

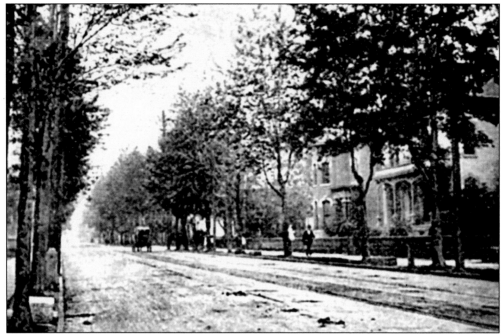

A buggy heads up a solemn West Main Street during the 1890s. Impressive homes lined the street back then. Dutchtown bordered this important route to Buffalo, and it was well settled early on. Some pioneers set their wagons back off the road in little groves and lived out of them as they built their small homes. A home along this section of West Main Street housed the Liederkrantz Club for years. (Courtesy Rochester Public Library.)

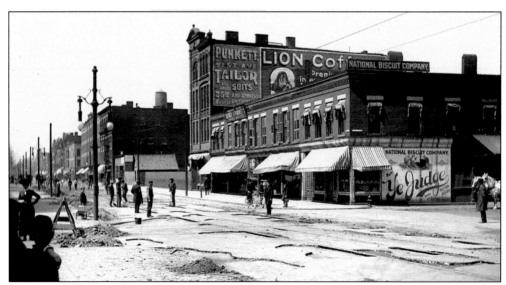

West Main Street is prepared for repaving in a photograph taken between 1900 and 1910. There are wood sidewalks. A sign on a building reads "Deer Harvesting Company." Along the residential side streets lived workers for Rochester General and St. Mary's Hospitals. Additionally, there were tailors, seamstresses, bricklayers, plasterers, and carpenters in the area. (Courtesy Rochester Municipal Archives.)

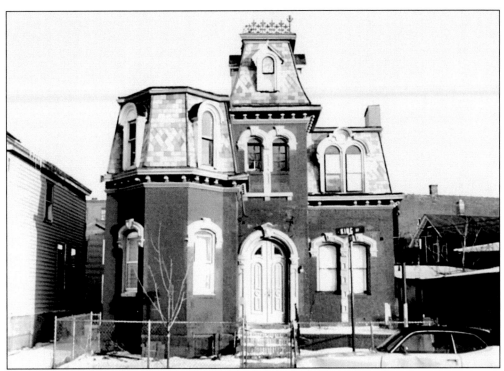

Along the southern border from Oak Street to West Avenue is an important neighborhood: Susan B. Anthony Square, a historic district most noted as the home of the famous suffragette Susan B. Anthony. This Second Empire home at 8 King Street is an example of the district's rich architectural heritage. It was built in the 1870s for Henry Fish, the proprietor of a transportation and warehouse business. Note the mansard roof with its iron cresting and the round-headed hood moldings over the door and windows.

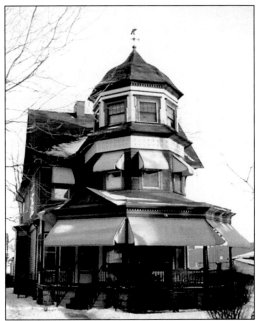

This impressive home with an octagon tower and scalloped shingles stands at 16 Madison Street. Some families who moved to this section prior to the Civil War passed the homes on to successive generations; the last left in the 1970s.

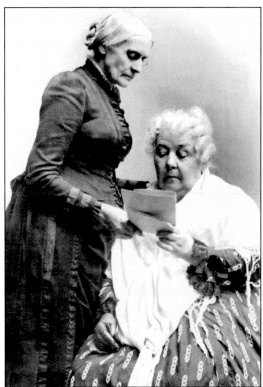

Susan B. Anthony and Elizabeth Cady Stanton had one of the greatest friendships in American history. They worked for women's rights, abolition, and temperance. Their hard work certainly benefited the working-class neighborhood to the north. Susan lived with her sister Mary at 17 Madison Street. Their sister Hannah lived next door.

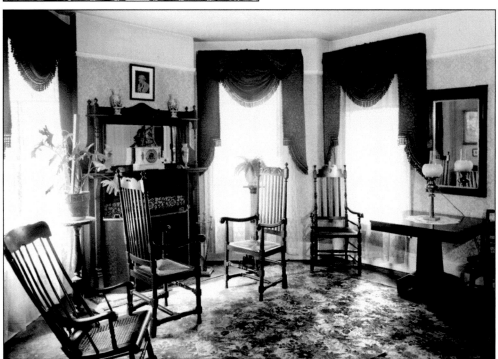

The restored sitting room of the Susan B. Anthony house is shown in August 1968. The photograph was taken by J. Carl Burke Jr. for the Historic American Buildings Survey.

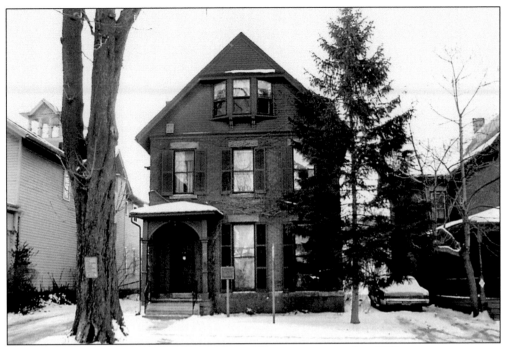

The Susan B. Anthony House and Museum is shown as it appeared in 1982.

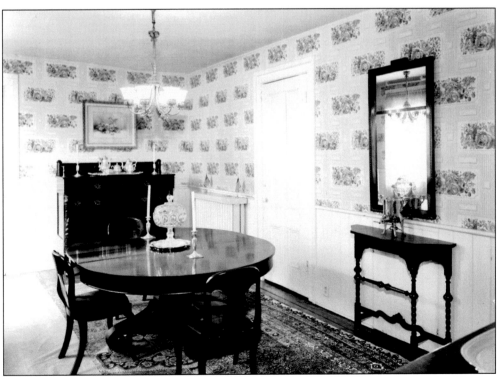

The restored dining room was photographed in 1968 by J. Carl Burke Jr. for the Historic American Buildings Survey.

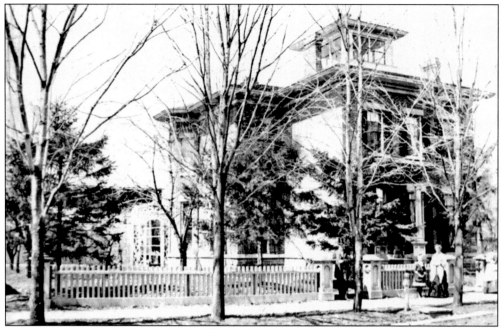

This beautiful brick residence at 27 Madison Street was built in 1878, when the neighborhood was at its peak, for the cost of $3,500. The family that lived here is pictured along the front fence. Stephen Coleman is standing between the gateposts. To the right are his wife, Jane, and daughter Lillian. The house stayed in the family into the 1970s. Coleman ran a business in the Brown's Race industrial district. (Courtesy Landmark Society of Western New York.)

An early postcard view of the square shows homes along its perimeter. Originally, it was called Mechanics Square after the workers who lived there and applied their skills in the Canal-Litchfield Streets industries. Later it was designated Madison Square and finally Susan B. Anthony Square. Today a life-sized statue of Susan B. Anthony and Frederick Douglass talking over tea has been set in the park. (Courtesy Landmark Society of Western New York.)

SS. Peter and Paul Church was an important part of Mechanics Square (now Susan B. Anthony Square). Established in 1843, it stood on the corner of Maple and King Streets until 1910, when it was demolished. The German congregation then moved to its beautiful new edifice on West Main Street. An interesting facet of Dutchtown's religious history deals with an Episcopal church that stood nearby at Broad and Jay Streets. The congregation, dating to the 1840s, was comprised of Irish Protestant parishioners. The Irish were predominantly Catholic.

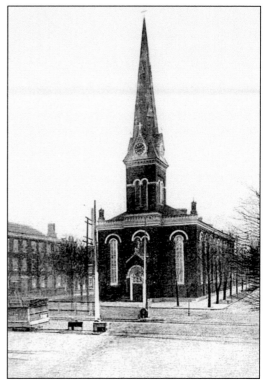

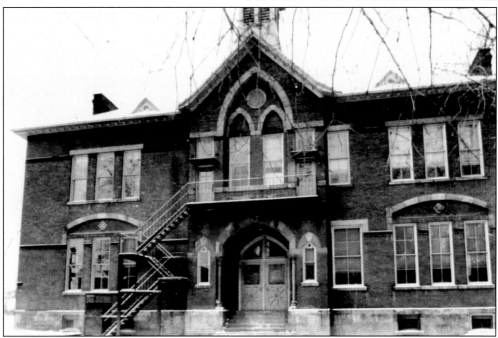

School No. 2 was built in 1874 on King Street, across from the square. It replaced an earlier 1843 building. The school was used as the West Side School for Boys as well as the Madison Park Vocational School. Susan B. Anthony's sister Mary served as Rochester's first female principal here until she retired in 1882. (Courtesy Rochester Public Library.)

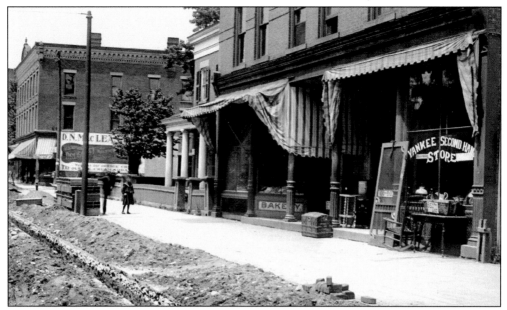

This young girl is in the midst of a number of shops capable of providing endless delights. This is West Avenue near King Street *c.* 1905. The bakery and the Yankee Second-Hand Store are seen. Behind her, on the corner building, are signs that read "Try our ice cream sodas" and "We make our own ice cream." There is a residence to her side. This area was across the street from the Rochester City Hospital (later Rochester General). (Courtesy Rochester Municipal Archives.)

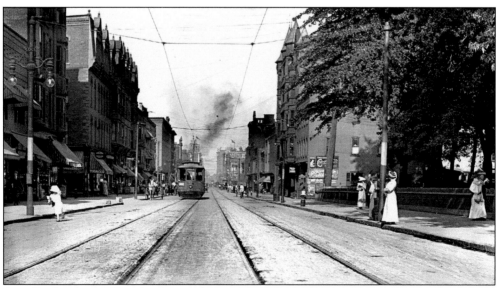

A trolley heads up West Avenue in August 1913. Rochester General Hospital is beyond the fence on the right. This view looks east towards downtown. The intersection with Litchfield Street is to the left. (Courtesy Rochester Municipal Archives.)

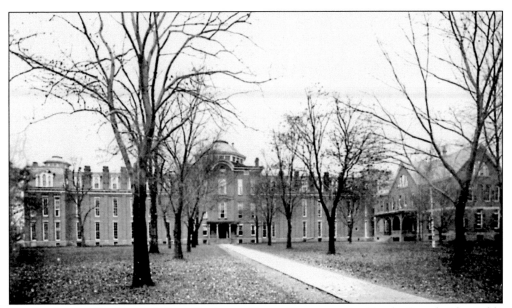

The Rochester City Hospital (later Rochester General) was organized by the Female Charitable Society. It opened in 1864 and cared for Civil War wounded as well as the afflicted citizens of Monroe County. Dutchtown folk made good use of the institution. With so many industries, there were endless injuries. Devastating outbreaks of cholera, scarlet fever, smallpox, and other diseases necessitated the building of makeshift hospitals outside the city limits. Mrs. Zahn, who lived on Silver Street during the early 1900s, supplemented the household income by selling milk from her dairy of a dozen cows to the hospital.

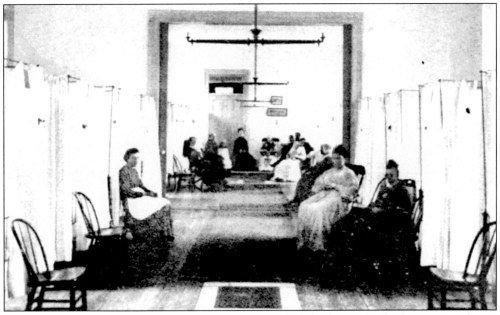

A stereoview from the 1870s shows the women's ward of the hospital. The long east and west wards were arranged with two rows of beds with a window between each. White curtains were hung from iron frames around each bed to provide privacy. The floors were covered with matting. Note the hanging gas lamps. (Courtesy Baker-Cederberg Archives, Rochester General Hospital.)

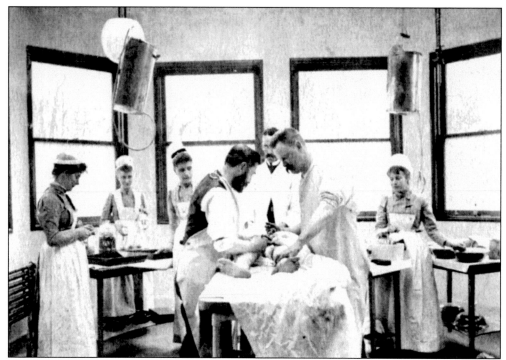

The new Whitbeck Surgical Pavilion at the hospital is pictured in 1892. Note the many windows for light. Prior to this, the operating room shared space with the library. Pictured at the operating table are doctors Charles D. Young (left) and Louis Weigel (right). (Courtesy Baker-Cederberg Archives, Rochester General Hospital.)

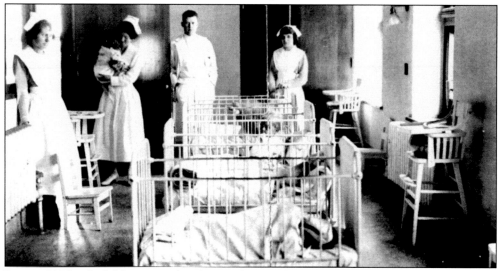

Prior to 1886, sick children were placed in wards with adult patients. This was the new Children's Pavilion, where a host of maladies were treated, such as abscesses, orthopedic problems, and St. Vida's Dance, a nervous disorder. A Dutchtown resident recalled, "families had a lot of children because they would lose some to disease." These devoted professionals certainly did their best to reverse that trend. (Photograph and information courtesy Baker-Cederberg Archives, Rochester General Hospital.)

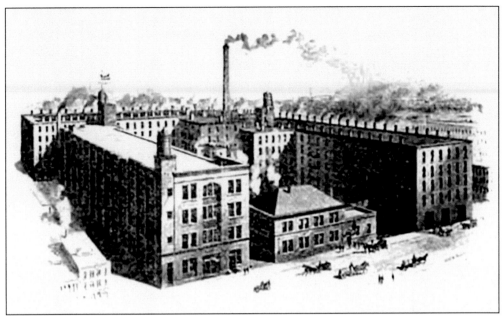

The Canal-Litchfield Streets industrial area was east of Madison Square. The largest manufacturer was James Cunningham Son and Company on Canal Street. It began in 1848 as a manufacturer of quality carriages, and it later produced automobiles. During both the world wars, the company produced military products. Cunningham became a subsidiary of Gleason Works in 1968.

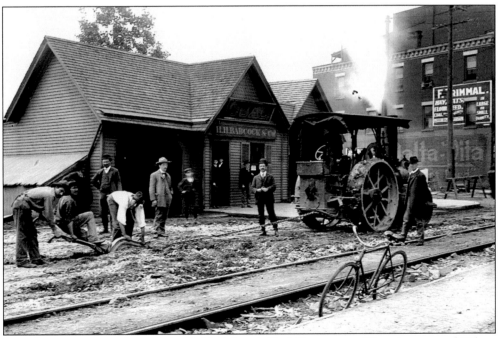

A work gang passes in front of the H. H. Babcock Coal Company at West Avenue and Hilton Street in 1905. The street is being gouged by a plow drawn by a steamroller. At the corner is Frederick J. Trimmal's hay and feed store. (Courtesy Rochester Municipal Archives.)

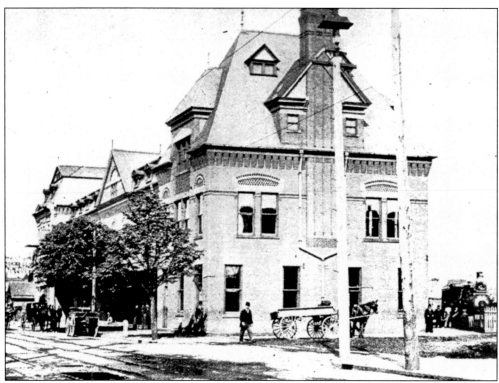

The Buffalo, Rochester, and Pittsburgh Railroad station at West Main and Oak Streets was originally the Pitkim Hotel. It provided accommodations for canal travelers. The center section was the hotel; the two asymmetrical towers at the ends were added in the 1880s. Prior to that time, the railroad was the Rochester and Pittsburgh Railroad. That line terminated at Lincoln Park, and a single track provided service to a station at Maple and Saxon Streets.

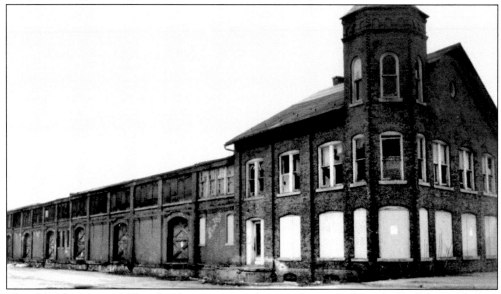

The old Baltimore and Ohio freight station stood across the tracks from the Buffalo, Rochester, and Pittsburgh depot.

Four

AROUND DUTCHTOWN

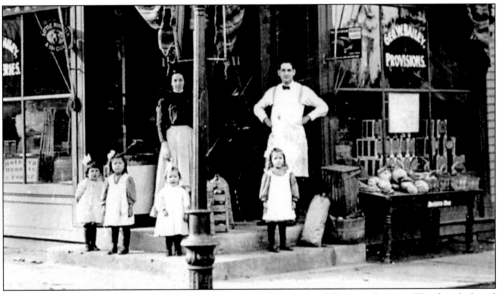

George W. Bailey's Groceries occupied the corner of Grape and Orange Streets. The family lived upstairs. That is George Bailey and his sister Cora. On the left are George's three daughters, Florence, Agnes, and Catherine (order not known) and on the right is a friend. Fresh produce is on the small table. "In the fall the stores put out crates of grapes for winemaking time. The streets smelled of grapes," a resident recalled. The Germans got their seasonings here to make their sauerkraut and sausage. Those aromas penetrated the streets, as would the smell of simmering tomato sauce when the Italians made pots of it on Sunday. This area of Dutchtown is where the two nationalities came into conflict. "Don't let any German tell you Dutchtown was clean. It was filthy! The Italians are the ones that cleaned it!" a longtime resident recalled musingly. A neighborhood German nearly as old responded, "There was no crime until the Italians came in. They were with the Mafia and they all had knives!" Fortunately, these sentiments elicit laughs now. A store still operates at this location. (Courtesy Julia Monastero.)

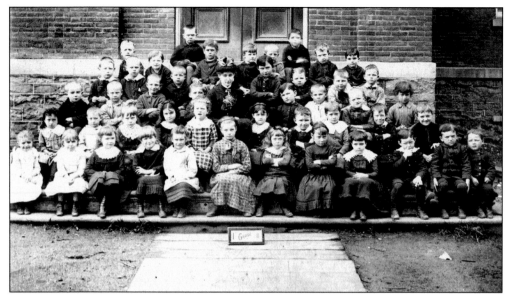

The first-grade B class poses for a portrait outside School No. 6 in the early 1900s. The school, located at Lyell Avenue and Frank Street, opened in 1853. Other area schools included John Williams No. 5, William Fitzhugh School, Whitney School No. 17, General Elwell Scott Otis School No. 30, Theodore Roosevelt School No. 43, Edison Technical and Industrial School, Jefferson High School, and Continuation School. (Courtesy Rochester Public Library.)

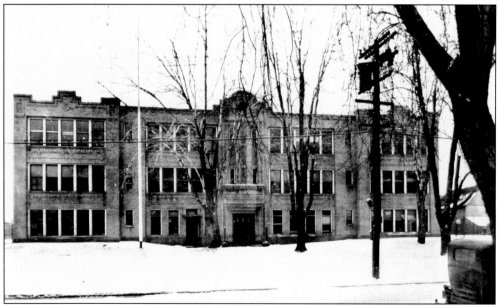

Jonathan Child School No. 21 was built in 1921 on Colvin Street near Jay Street. It was named for Rochester's first mayor and replaced an 1878 frame school that stood on Jay Street. School No. 21 closed in 1982, and the building has been converted into senior housing. A former student remembered fondly, "It was a beautiful, beautiful neighborhood. We raised money for the school by selling fritters and packets of Morton salt. There was a nearby factory. I would peek in the window early in the morning and they let me in. The workers all bought from me, saying I was the best salesgirl." (Courtesy Rochester Public Library.)

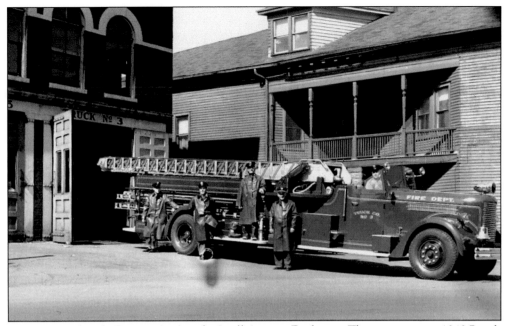

Firemen pose beside Engine No. 3 at the Lyell Avenue Firehouse. The engine is a *c.* 1948 Pirsch 65-foot aerial or hook-and-ladder truck. Many firefighters believed Pirsch made the Cadillac of hook-and-ladder trucks. (Courtesy Thomas DellaPorta.)

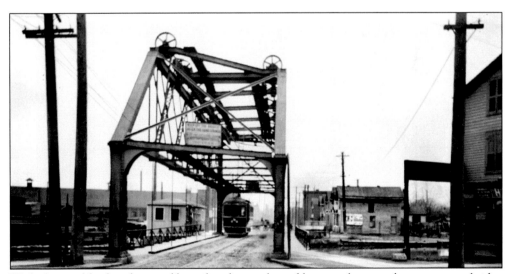

With the neighborhood pierced by railroads, canals, and later a subway and expressway, a bridge seemed to be waiting at every turn. A streetcar travels across the Lyell Avenue Bridge over the Erie Canal in September 1897. This was a vertical lift bridge. The bridge captain would sound a series of gongs to warn people to leave the bridge at once so that he could raise it. (Courtesy Rochester Municipal Archives.)

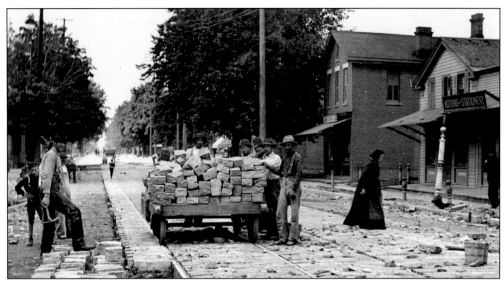

A work gang is setting brick paving stones around streetcar tracks during the repaving of Lyell Avenue in September 1897. Small homes to the right have been converted to businesses. These work gangs tended to be made up of the more destitute Italian immigrants, who were comparable to early migrant workers. Some lived in labor camps, where violent outbreaks occurred regularly. Charitable societies, churches, and Italian agencies helped when they could. Before long, these men were becoming foremen and opening contractor businesses of their own. (Courtesy Rochester Municipal Archives.)

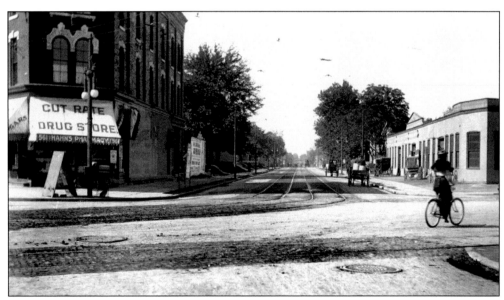

The intersection of Lyell and Lake Avenues is shown in a photograph taken October 5, 1899. George Hann's Pharmacy is to the left. Across the street, on the corner, is R. J. Smith, a carriage and bicycle manufacturer. Lake Avenue was lined with impressive homes that needed lots of maintenance. Irish, German, Italian, and other immigrants often found work in them. (Courtesy Rochester Municipal Archives.)

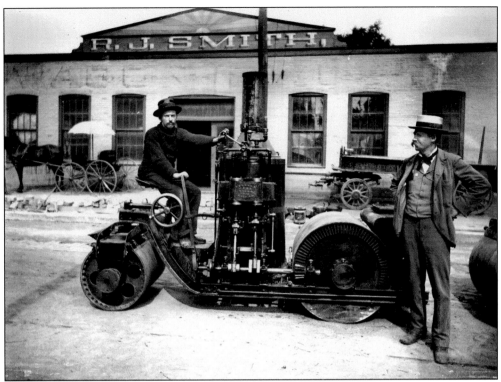

A vehicle operator and another fellow stand rather proudly beside an interesting piece of road equipment, a steamroller used to compress pavement. The photograph was taken October 1, 1897, during road improvements to Lyell Avenue. Behind the men is R. J. Smith, a manufacturer of carriages and bicycles. (Courtesy Rochester Municipal Archives.)

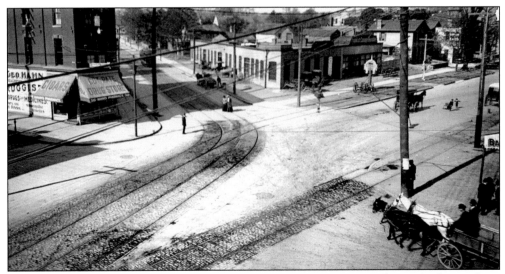

An elevated view of the State Street and Lyell Avenue intersection in the 1890s shows why it was called "Five Corners." Lake Avenue, Smith Street, Vincent Street, Lyell Avenue, and Lake Avenue all converged here. (Courtesy Rochester Municipal Archives.)

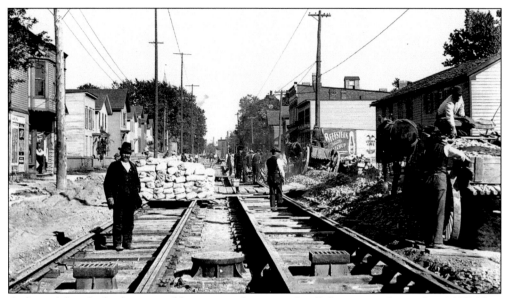

Arduous labor, by both man and beast, is underway on Lyell Avenue in September 1897. New streetcar tracks have been spiked and graded, and paving is ready to get underway. (Courtesy Rochester Municipal Archives.)

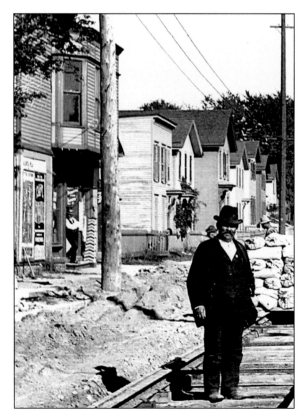

A detail from the top image shows small homes and businesses packed together along Lyell Avenue. Among the many businesses were undertakers. A resident recalled, "Back then the dead were laid out in the house. The undertaker would come and get the body. He would do the embalming and usually his wife would dress the body. The family would put a black wreath on the front door. When we were kids we had to be quiet when we passed and make the sign of the cross." (Courtesy Rochester Municipal Archives.)

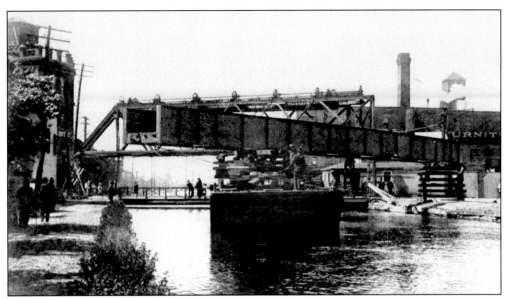

The Lyell Avenue footbridge over the canal was an unusual plate girder swing bridge. Pictured here in 1902, it was located where the avenue crossed the canal at what later became Broad Street. Small industries lined the waterway, and the yards of many homes backed up to the canal. Some residents would keep a small rowboat tied up and offer transportation up to Main Street for a nickel, which was better than walking or paying a trolley fare. (Courtesy Rochester Public Library.)

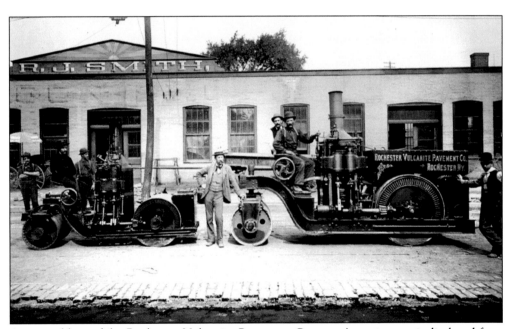

An assemblage of the Rochester Vulcanite Pavement Company's equipment is displayed for a photographer on October 1, 1897. Lyell Avenue road improvements were underway. Many of Dutchtown's streets were paved with cobblestones or brick. Later they received thick layers of tar pavement. It was a common to see the old brick reappearing through the worn pavement, especially after a harsh winter. (Courtesy Rochester Municipal Archives.)

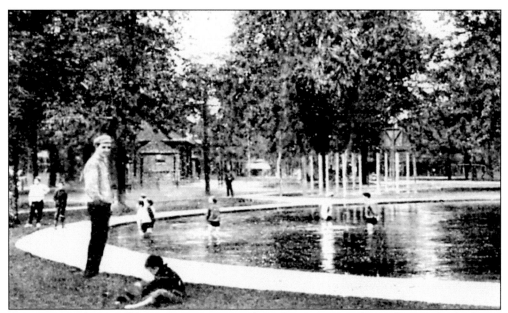

A rare postcard view of Brown Square c. 1910 shows boys enjoying the wading pool, which was often referred to as the "mud pit." When the neighborhood was mostly German, there were regular beerabend festivities and other traditional celebrations in the square. As the Italians gradually replaced the Germans in the area, the square became the site of religious festivals, usually in honor of the saints. Processions through the streets would end here, and there would be picnics, services, and music all under Japanese lanterns. Today the square hosts music festivals and events sponsored by the Brown Street neighborhood association.

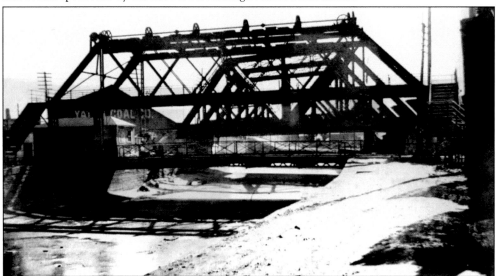

The canal passed under the Allen Street lift bridge and then a railroad bridge, as seen in this photograph taken in March 1902. Kids did not have to travel far down Allen Street to find adventure thanks to all the burgeoning commerce, industry, railroads, and canal activity. There were two stores that former residents can remember from the 1940s; Mary's Gift Shop and a store called Gargano's, where peanuts were roasted. Other nearby businesses manufactured chewing gum, potato chips, soda pop, and tomato sauce. (Courtesy Rochester Public Library.)

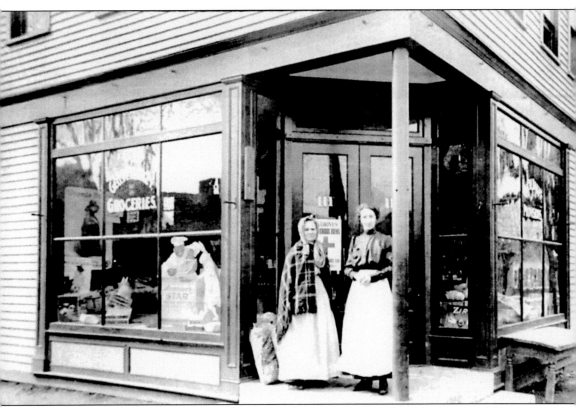

George W. Bailey's Groceries, pictured here and on page 79, stood on the corner of Orange and Grape Streets. Former residents fondly recall these stores by the nicknames they gave them when they were children. Bailey's later became Metchgee's. "There was Smith's Bakery, Simonette's, Pennepento's saloon and store," a resident recalled. "Nebbia's on Jay Street had chickens in cages outside. They had live turkeys at Thanksgiving and lambs at Easter. Fathers would bring the lamb home and kill it in the cellar. We would hear the little thing 'bah-a-a-ing' down there. Nebbia's put out so many crates of fruit and vegetables you could hardly get down the sidewalk. He left everything out all night. They threw tarps over it and no kid ever stole a single thing!" Another favorite store was called Peppanut's. "They had everything in there: hardware supplies, penny candy, toys—everything! At Christmas he had glass ornaments from Germany. He sold Christmas trees, and he would put one in his window. Not every family put up Christmas trees then. Peppanut's window was like the neighborhood Christmas tree. It was beautiful when lit and with toys beneath it." (Courtesy Julia Monestero.)

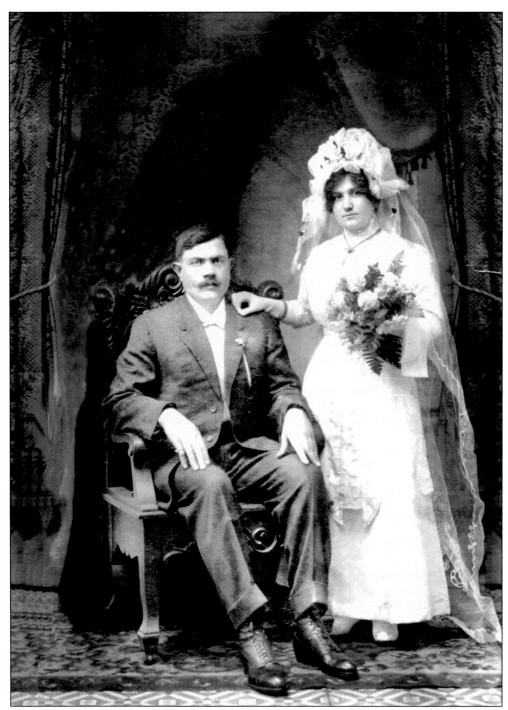

The newly wedded Matteo and Mary Angela Lombardo pose on Valentine's Day in 1914. A sponsor brought both of them to America. They lived in several homes around Dutchtown before settling into the house at 22 Walnut Street, where they raised 10 children. For over 80 years, the Lombardos had a presence in Dutchtown; the last of them left in 1999. Matteo and Mary Angela are the authors' maternal grandparents.

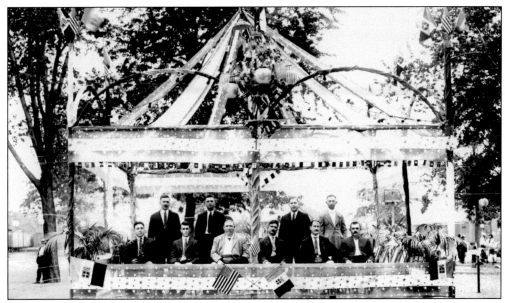

One of the ways immigrants learned to cope with their new lives in America was to form societies with like-minded folk from the old country. Traditions were kept alive, and this support led to immigrants being accepted in neighborhoods where they had not always been welcomed. Here, a society of men from the same region of Italy celebrates at Brown Square. Their booth is regaled in Italian and American flags as well as Japanese lanterns. Street bands dressed in flashy uniforms provided the music. Other entertainments included bocce games. Matteo Lombardo is sitting on the far right.

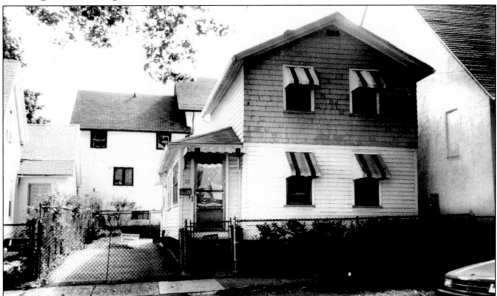

Matteo and Mary Angela Lombardo came to live at 22 Walnut Street in the 1920s. The house, built in the 1860s, had gas lamps and was heated with a potbelly stove in the dining room. The Lombardo's son Frank was a handyman. He made many improvements to the house; these included installing a trolley window and remodeling the kitchen, which he finished with unique white glass squares. At Christmas the house was filled with family and friends.

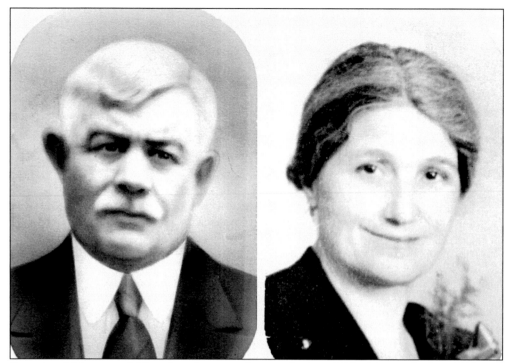

Portraits of Matteo and Mary Angela were taken in the late 1930s. Matteo died in 1941, and Mary Angela raised her 10 kids by herself. She once remarked, "I raised ten kids alone and not once did the police come to my door, telling me one of you were in trouble."

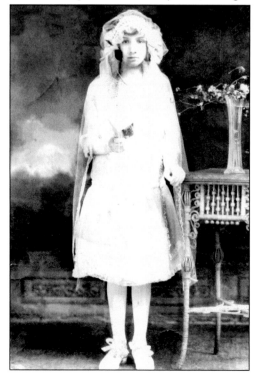

The authors' mother, Mary Lombardo, poses for her confirmation photograph in the early 1930s. She remarked on the Italians' skill in photography. "There were a lot of good Italian photographers. They had studios over at Mill and State Streets and over near Campbell. They were the best," she recalled. "They would even come to the house back then."

Mary Angela and her son Tony pose in their small yard on Walnut Street. She is still wearing black, as she is in mourning. The children all had their chores: washing clothes, baking, canning preserves, cooking, ironing, and cleaning the house. When they got jobs, a portion of their pay went to the household.

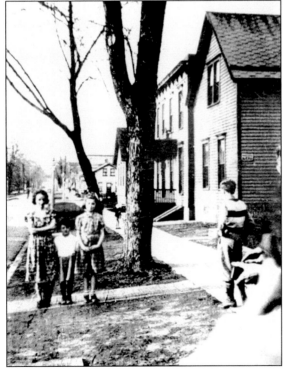

Youngsters play in front of the house on an evening during the Great Depression. The canal-era homes had small yards and no driveways. Families raised chickens, rabbits, goats, and lambs for food. Some kept pigeons to make soup. There were always peddlers coming by in their horse-drawn carts, which brought the kids running. "Something was always going on: Halloween parties, band concerts at Brown Square, or fireworks at Jones Square," a resident recalled. "Things are better today, I suppose, but we miss those days. Life was hard, but we were happy."

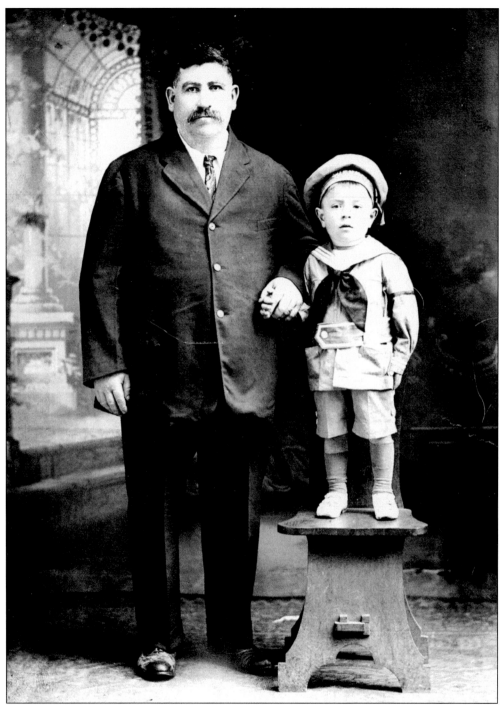

The lad in this c. 1918 photograph is Frank Lombardo. The gentleman holding his hand is Gabrielle "Gabes" Romanola. Gabes sponsored Frank's parents, Matteo and Mary Angela, helping finance their immigration to America from Italy. He was a prosperous and kindly benefactor who brought a number of Italians to America. Frank will be 90 years old soon and remembers the old neighborhood as if it were yesterday.

Martha, Lena, and Tony Lombardo pose in the yard of their Walnut Street house. They often spoke of the days when horse-drawn peddler wagons rumbled down the brick street. "There was 'Fishman,'" a family member recalls. "He blew a long tin horn so the women could hear in the house. *Pesce! Pesce!* (Fish! Fish!) he called. The wagon always had a million flies around it. And then there was 'Iceman,' who came with blocks of ice for five cents for the old wood ice boxes." The clatter of the horse and wagon of the "Ragman" was also common. "He was an old Jewish man with a long beard. He would buy any paper or rags you had, which were made back into paper."

Tony, proudly attired in his baseball uniform, is ready at bat in a photograph taken April 28, 1940, in his backyard. Any open sandlot or park would do for a game. "Baseball was everything then," a resident recalled. "There were always games at the school lots. The local stores and saloons sponsored teams. Even the girls played. The game was taught at school."

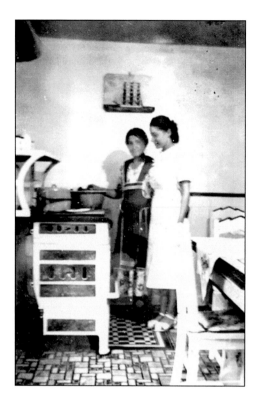

A rare look at a 1930s kitchen is provided in this image of Mary Angela and daughter Rachel. The old gas stove was always going, and it helped to heat the house in winter.

Proud grandma Mary Angela shows off her first grandson, Johnny, born to daughter Rachel and her husband, Carl Branca, who lived across the street. It was common then for families to stay in the neighborhood. "It was like heaven," a neighbor recalled. "There were flowers and music. It was clean. The guys got together to listen to the Friday night fights on the radio. The women took the bus downtown to shop. We kids could walk to the Lincoln Theater on Jay [Street] or to the Murray. The gals would go to buy cups and dishes the shows offered then."

Mary Angela enjoys her garden with her son Michael and grandson Johnny. Michael was wounded in the battle of Normandy during World War II. He died in 1952 at age 29.

Mary Angela poses with her granddaughter Agnes in the front door of the Walnut Street house.

Louis Luciano (sitting) and friend Andrew Lombardo pose for their confirmation photograph in 1939. Adherence to Catholic traditions kept the family strong. Like their German counterparts, Italian offspring were getting away from speaking their native language. However, Italian newspapers and radio programs continued to use their native tongue. Italians continued their struggle to gain ground in civic, business, and political affairs. Increasingly, they became noted business leaders, teachers, engineers, doctors, and lawyers.

St. Francis of Assisi Church was established in 1929 on Whitney and Orange Streets in an old movie theater. The congregation later built an adjacent hall on the corner of Campbell and Whitney Streets where they held bingo, dances, and other events. The nearby Charles Street Settlement House has had a long association with the church, having worked with European newcomers in the early 20th century and continuing to provide activities for seniors and children today.

At about 1:45 a.m. on May 2, 1945, the Lombardos' house and just about every other in the neighborhood shook from what sounded like a loud explosion. Mary Angela cried, "It must be the train!" and she was right. The engineer of the New York Central passenger train *Wolverine* hit the Oak Street curve at about 70 miles an hour. The train derailed and crashed down the embankment, killing the engineer and injuring about 48 passengers and employees. (Courtesy Thomas DellaPorta.)

A view from the rail line the next day shows the extent of destruction. Mary (Lombardo) Leavy remembered that night: "The whole house shook! Everyone got out of bed and ran down the streets towards the tracks. All the kids were excited but afraid. You could hear the ambulances and fire bells ringing as rescue crews were coming in from all over the city." (Courtesy Rochester Public Library.)

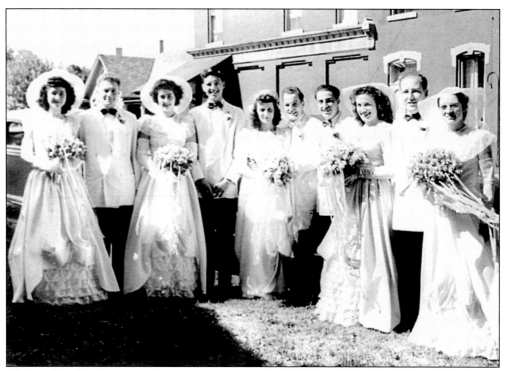

The neighborhood came to life when there was a wedding. Newlyweds Francis and Mary Leavy, seen in the middle holding the bouquet, pose with their wedding party in front of the Walnut Street house in 1947.

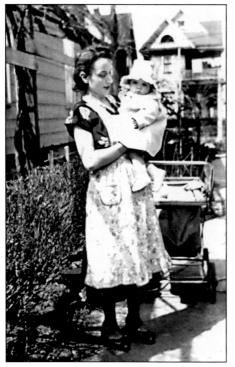

Mary Leavy shows off her daughter Diane beside their Smith Street apartment in 1949. Postwar prosperity allowed offspring to move to higher-end neighborhoods, although their parents generally preferred to stay in Dutchtown. Some moved to Gates, which became known as Little Dutchtown, and others went to new subdivisions in Greece and Irondequoit. Mary, Frank, and Diane stayed in their modest apartment for a few years before moving to Garfield Street in the 11th Ward, south of West Avenue. The house they bought was originally in Dutchtown and was moved to Garfield Street in 1951.

Shrines were common in a neighborhood where religion figured heavily in family life. Usually, old claw-foot bathtubs were partially buried and a statue of the Blessed Virgin Mary was set inside. Frank Lombardo custom-built this shrine with stonework, glass, and lights. It was also surrounded with beautiful flowers. Larry Lombardo reminisced, "Couples out for a walk after dinner would stop by the sidewalk fence and say their prayers at the shrine. We would see them through the window."

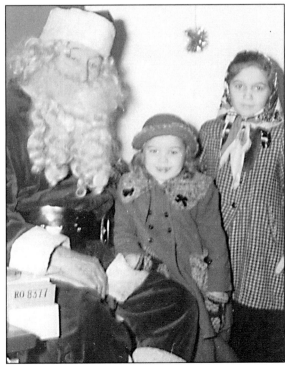

Two of Mary Angela's granddaughters, Diane (center) and Agnes, have their photograph taken with Santa at Sibleys in the early 1950s. Going downtown, especially at Christmas, was exciting back when there were big department stores along Main Street.

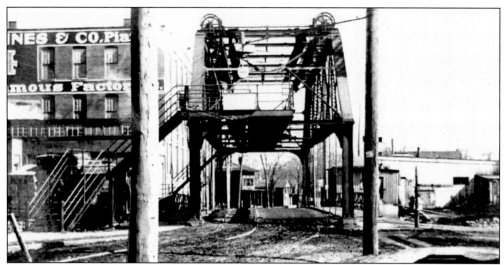

Allen Street crossed the Erie Canal via this short span plate girder bridge built in 1879 by Leighton Bridge and Iron Works. Seen in this March 6, 1902, photograph, it is believed to have been the first lift bridge in the city. Allen Street was filled with endless delights for children, who usually formed into little gangs when freed from parental supervision. There were dry-goods stores, ramshackle lumberyards to explore, and markets with poultry stands and vast selections of candy. (Courtesy Rochester Public Library.)

Policemen pose beside downtown's city hall in the later part of the 19th century. Dutchtown had its share of crime, which required a stern police presence. Later, bootlegging, prostitution, Mafia extortion, and gang fights kept the precinct phones ringing. Crimes against Italians, particularly beatings, led to the creation of protection groups. "When we were children, we would be walking down the street and someone would come out and yell, 'Get off our sidewalk you little dagos!'" a resident recalled. "If we said anything, they would call the police. Our parents taught us to keep our mouths shut." (Courtesy Rochester City Hall Photo Lab.)

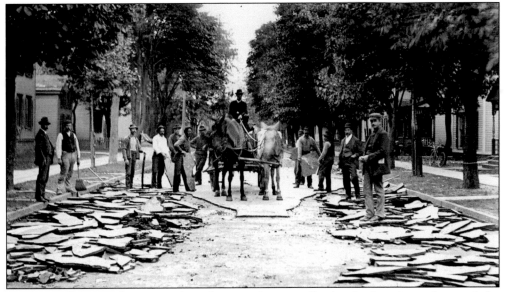

Repairs are being made to a residential street. A steamroller has broken the surface, and the sections are being loaded into the wagon. Italian laborers were gradually promoted to positions as foremen. In time, some started their own construction companies. Note that there are no driveways. (Courtesy Rochester Municipal Archives.)

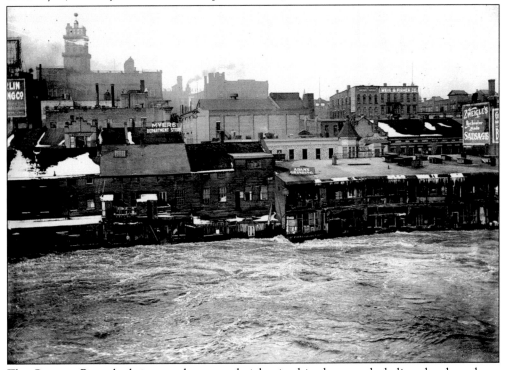

The Genesee River had risen to dangerous heights in this photograph, believed to have been taken during the flood of March 28, 1913. The buildings in the foreground faced Front Street. One of the businesses pictured is Weis and Fisher Company, located at 279 Brown Street. (Courtesy Rochester Municipal Archives.)

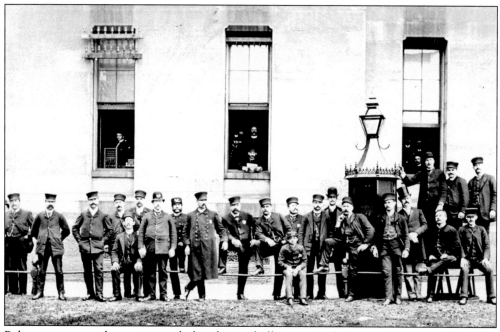

Policemen pose rather expressively beside city hall sometime between 1875 and 1895. "The Irish made good cops," a former Walnut Street resident said. "We would play baseball in the street and the Germans would tell the cops. Before you knew it officer Charlie, a big Irish fellow, would come riding down the street on his horse and chase us off. He was pretty good about it though." (Courtesy Rochester City Hall Photo Lab.)

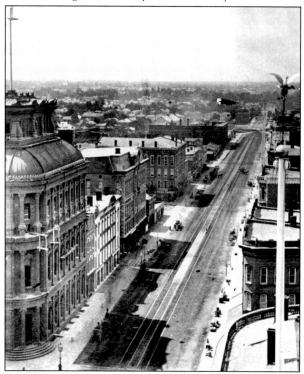

This stereoview from the 1870s, taken from the top of the National Hotel (later Powers Hotel), looks west down West Main Street. Rochester Savings Bank is on the right. There are parallel tracks for the horse-drawn streetcars that went into service during the Civil War.

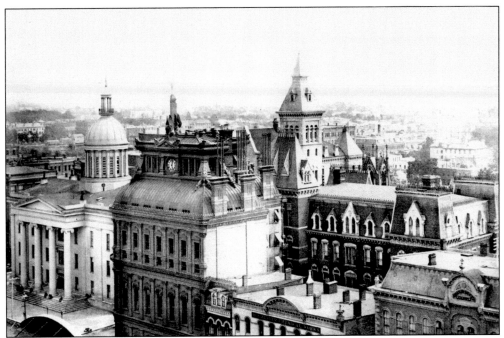

The city has a darkly imperial quality in this view from the late 1870s. Among the buildings pictured are the courthouse, Rochester Savings Bank, city hall, and the Rochester Free Academy. (Courtesy Rochester Public Library.)

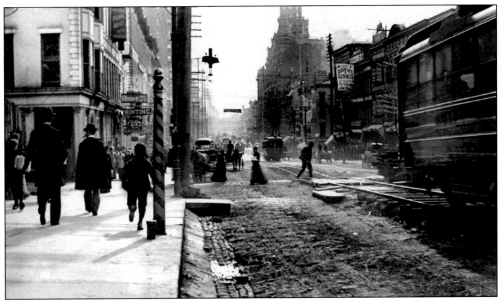

A busy August day in 1893 finds Main Street greatly in need of road repairs. A cobblestone street gutter carries storm runoff. City health officials were always working to improve water quality, milk pasteurization, and sanitary conditions. (Courtesy Rochester Municipal Archives.)

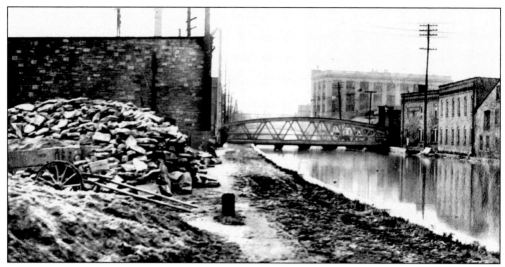

The Erie Canal was nearing the end of its run through the city when this image was taken sometime between 1922 and 1927. For decades, tenements backing to the canal had up to 50 immigrants living in three or four rooms. Conditions were frightful, with open sewers running through the basements and rubbish piles outside. Health authorities had carts haul refuse from the canal, but they dripped their filth along the streets. Much of it was dumped in the river. "The whole central portion of the city was filled with a stench," a resident recalled. (Courtesy Rochester Municipal Archives.)

Parts of the Erie Canal bed through the city were used for the new Rochester subway. Passengers get on and off an eastbound subway car at the Oak Street Station on April 5, 1940. (Courtesy Rochester Municipal Archives.)

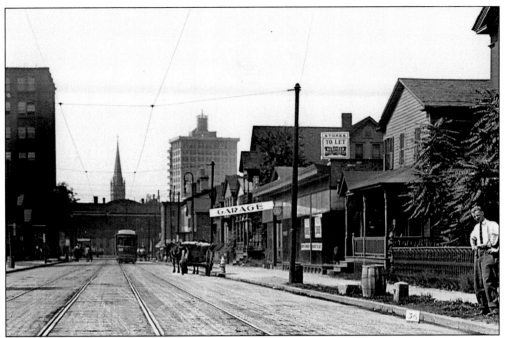

The spire of St. Patrick's Cathedral and the Kodak tower are visible at the end of North Plymouth Avenue in a photograph taken August 18, 1913. The view looks north between Church and Commercial Streets. A mix of homes, churches, factories, and bakeries made this section of the avenue colorful. (Courtesy Rochester Municipal Archives.)

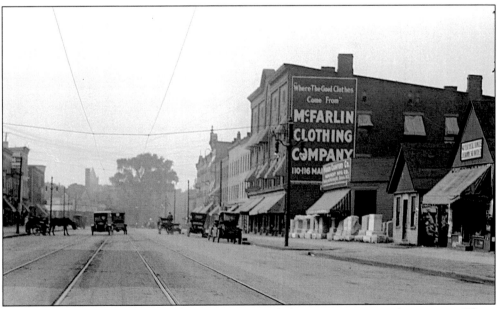

This view of State Street north of Jay Street in 1913 shows some mom-and-pop stores. These were usually family-run businesses in simple commercial structures that were often added to the fronts of the proprietors' homes. (Courtesy Rochester Municipal Archives.)

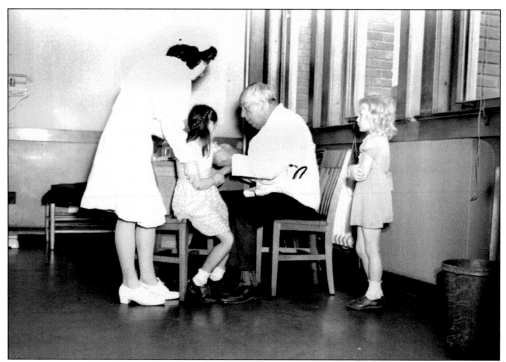

Doctor Harry C. Hummell appears to be giving a girl an inoculation on June 12, 1945, at John Williams School No. 5, located at North Plymouth Avenue and Jay Street. Public health improvements were addressed in earnest after devastating outbreaks of cholera and smallpox in the early days of the city. Scarlet fever and polio continued to devastate families into the 1950s. "If a child had scarlet fever," a resident recalled from her experience in the 1940s, "the health board quarantined your house. A notice was put on your front door telling people to stay clear." (Courtesy Rochester Municipal Archives.)

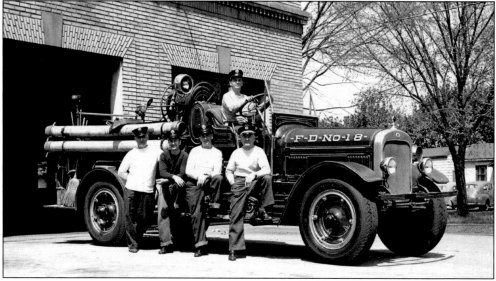

Firemen pose beside their highly polished Engine No. 18 outside the doors of the Child Street Firehouse. (Courtesy Thomas DellaPorta.)

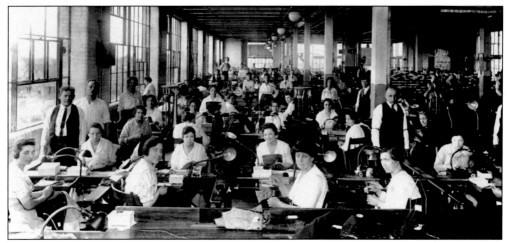

This garment factory, believed to be Michael Sterns in Dutchtown, was much improved from the old sweatshops where women and children were subjected to long hours, low pay, and terrible working conditions. A report issued during a garment strike noted, "Girls sit in unsanitary and unventilated rooms for ten hours a day stitching garments." Immigrants working below union wages caused problems as well. Many homemakers made extra money doing piecework. "We would go with the baby in the stroller to the clothing factory, pick up clothes that needed hand stitching, throw them over the stroller and go home," a woman recalled about the neighborhood in the 1940s. (Courtesy Rochester Public Library.)

Fire horses, dashing three abreast, pull a steaming fire engine to the scene of a fire. These animals were treated royally by the proud firefighters who depended on them. Their livery was kept in top shape. Often they wore colorful plumes on their heads. A resident told of a close call: "I heard the bell clanging and the horses coming. The horseshoes were sparking on the brick street. I ran onto a church lawn. It was on a corner and the horses cut the corner short, coming right across the lawn. I swear the horses were coming right at me!"

Decorative brackets supporting a peaked overhang on a Jay Street house survived at least until the early 1970s, when this photograph was taken. The wonder of siding put an end to a lot of the scalloped shingles and clapboards of yesterday. Although the neighborhood was comprised of modest houses, decorative flourishes were common, and most architectural styles were represented. Replacing a worn-out storm door with an aluminum one was often a big deal, especially when it had the initial of the family's last name in the center. "It was a mark of status—a step up, like a family coat of arms," a resident remarked. (Courtesy Landmark Society of Western New York.)

Originally situated beside the canal at Jay Street, this corner structure has always been a favorite meeting place. During German times, beer and Limburger were served here. In this photograph from the early 1970s, the building houses Rocky's Grill and Saloon. The neighborhood still had a lot of Italian Americans then, though many of the Germans had left. A number of old-timers just could not say goodbye to the neighborhood, however. Today there are descendants of the old families choosing to remain in Dutchtown. A view of this building in the canal days can be seen at the bottom of page 38. (Courtesy Landmark Society of Western New York.)

This impressive structure at 171 Lyell Avenue has housed several financial establishments. It opened in 1931 as the Union Trust Company, and in 1954 it became a branch of the Genesee Valley Union Trust. Lyell Avenue has always been a busy urban street of homes, industries, schools, and churches. It experienced a period of deterioration for several decades, but it is now in a state of revitalization. Rival gangs, such as the Jay Street gang, caused a lot of unrest. (Courtesy Landmark Society of Western New York.)

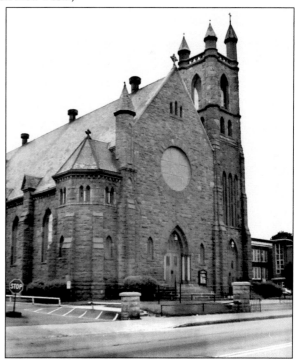

A noted landmark of Lyell Avenue is Holy Apostle Church. In the 1960s, Puerto Rican and African American families began moving into the largely Italian neighborhood. Holy Apostle continues to offer a mass in Spanish.

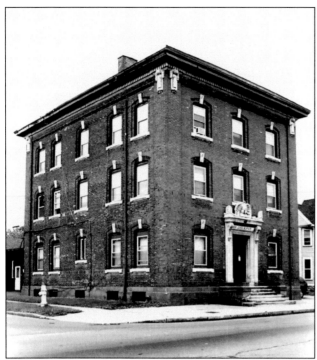

This old precinct house on Lyell Avenue has been adapted to other uses. Note the elaborate front entrance with its eagle. Along this strip were neighborhood institutions that brought former residents back into the city for generations; among these were Roncones Restaurant and Tent City.

Few stores could elicit joy in children as did Lyell Avenue's premier attraction, Tent City. There were shelves packed to the ceiling with toys, aisles of clothes—particularly for workingmen— and a selection of the greatest camping tents to be found, most of them set up for inspection. The store was an outfitter, carrying camping gear such as propane lanterns and stoves, hiking boots, sleeping bags, and anything else that was needed for treks into the wilderness.

Decorative brickwork embellishes the storefront of Petrillos Bakery at 664 North Plymouth Avenue, pictured here in the early 1970s. There were nearly a dozen bakeries in this area at one time. Like Lyell Avenue, North Plymouth Avenue was a once vibrant thoroughfare of shops, barbers, saloons, pool halls, and markets interspersed with homes. Increasing commercialization of the area made it undesirable for family life. Many remember the more colorful days of Tuesday night Bingo, wedding receptions at party houses, and Friday night fish fries. (Courtesy Landmark Society of Western New York.)

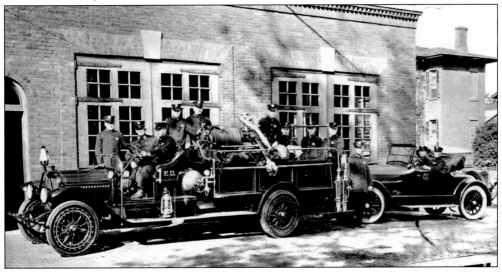

Firefighters of Hose No. 38 pose with their truck beside the firehouse at Platt Street and Frank Street (now North Plymouth Avenue). Pictured here, from left to right, are the following: Charles Dunbar, Capt. Stephen Efing, Edward Pfaff, Carol Foos, James O'Keefe, Henry Hoderlein, Charles Heinrich, Jay Dickerson, John Smith, William Glynn, acting battalion chief David Levy, and Thomas Slattery. (Courtesy Thomas DellaPorta.)

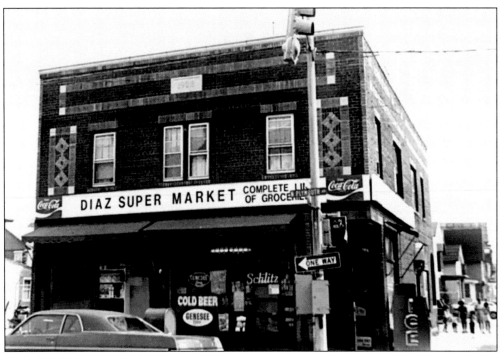

A store at the corner of North Plymouth Avenue and Smith Street exhibits decorative brickwork. The population of Dutchtown was predominantly African American and Puerto Rican when this photograph was taken in the early 1970s. (Courtesy Landmark Society of Western New York.)

Joe Minardo's Auto Service kept a thriving business in old Firehouse No. 3 at 333 Frank Street (North Plymouth Avenue). This photograph was taken in the early 1970s. The structure has been incorporated into the new Frontier Field baseball stadium grounds. (Courtesy Landmark Society of Western New York.)

Westside Motors made use of this Queen Anne–style home at 666 Broad Street. It is seen here c. 1970. (Courtesy Landmark Society of Western New York.)

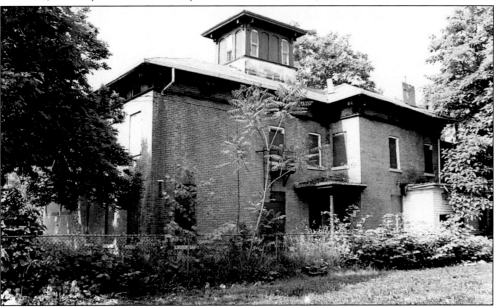

Dutchtown is at a crossroads. Crime, mostly drug related, has driven many older residents and working-class families out. Children fear passing boarded-up buildings because of lurking drug dealers who might harass them. Many neighborhood groups are combating the problems, however—not just in Dutchtown, but in other city neighborhoods as well. The planned construction of a soccer field will help boost the area, much as Frontier Field has. This once-impressive Italianate residence used to be known as "the judge's house."

Frontier Field baseball stadium was built at the end of Brown Square in an area once dominated by the Brown Street railroad yard.

In the mid 1950s, the I-490 highway (often called the Pit) was blasted through the heart of Dutchtown, cutting it in half and decimating its cohesiveness. For years, residents heard the loud whistle warning that a dynamite blast was coming. Many displaced residents moved to Gates, which still has a sizable Italian population. In 2004, the process began of rebuilding, in a highly stylized way, the original bridges that spanned the highway.

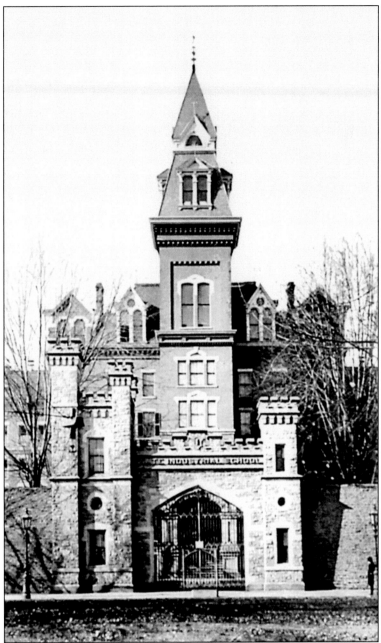

The State Industrial School, shown in 1890, originated as the Western House of Refuge in 1846. It was an institution of confinement and reform for male juvenile delinquents aged 16 and under who had been picked up for vagrancy and other criminal convictions. The 49-acre walled detention yards were along Dutchtown's border at the junction of Phelps Avenue and Backus Street. Nearly 400 delinquent boys were housed here prior to the Civil War. Many were orphans, and others had left abusive padrones or parents. At the refuge they were instructed in industry and agriculture. In 1907, the population was moved to a new location in Industry, New York. Eventually, Jefferson High School was built on these grounds. It was well attended by Dutchtown teens.

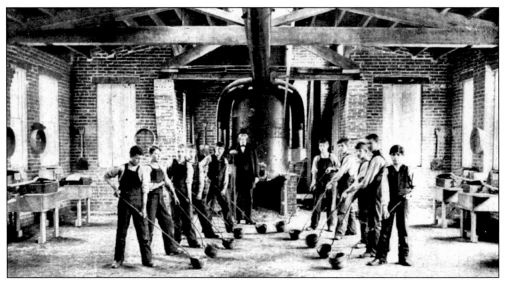

The boys seen in this 1887 photograph are posing in the foundry of the State Industrial School, where they are being taught the process of casting hot metal in molds. Other skills taught here included bricklaying, tailoring, shoemaking, machining, and a host of agricultural skills. The goal was for the young men to become self-sufficient. In 1875, a young boy, Antonio Pasche, sought police protection from an abusive padrone named Frank Perosle and gave an account of his harsh existence. Perosle brought him and 10 other boys here from Naples. They lived in a hovel along the gorge called Sleepy Hollow. Each boy was sent out daily to blacken boots, deliver papers, and do other tasks. If any returned with less than a dollar, they were beaten. Antonio was removed and put in an adoption home. (Courtesy Rochester Public Library.)

When the industrial school was relocated to Industry, New York, the old grounds were transformed into Exposition Park and, later, Edgerton Park. Edgerton was a wonderful tree-shaded complex with a museum, a zoo, an art gallery, agricultural exhibits, horse shows, and other events. German and Italian bands, with their impressive uniforms, gave concerts. The park's heyday ended with World War I. It continued in various forms, but never achieved its prior glory. A resident remarked, "Everything was at Edgerton—art gallery, museum, zoo. The rich wanted all of it on the east side, so they took it all over there!" (Courtesy Rochester Municipal Archives.)

116

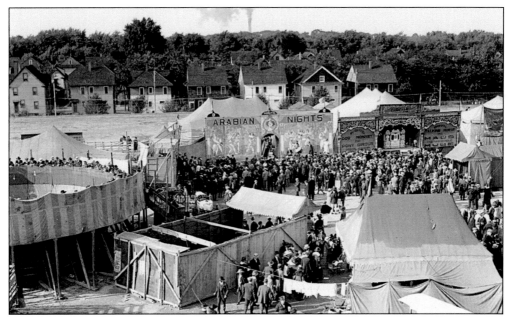

Crowds throng the midway at the Wonderful Dog, Monkey, and Pony Circus, held September 1919 at the exposition grounds. Exotic attractions included "Morita: Arabian Nights," "Maude the Unrideable Mule," fortune-tellers, and a talking horse. Dutchtown residents hastened to these exciting events. (Courtesy Rochester Municipal Archives.)

Much of Edgerton Park's allure was created by its majestic architecture. The large colonnaded peristyle was one of the more distinguishing features on the grounds. (Courtesy Rochester Public Library.)

There was no better place to drive your Studebaker to for a night of dancing to Frank Sinatra, Tony Bennett, and big band tunes than to the Stardust Room at Edgerton's ballroom. This January 28, 1950, photograph shows a woman on stage talking to young people, possibly about an upcoming show. (Courtesy Rochester Municipal Archives.)

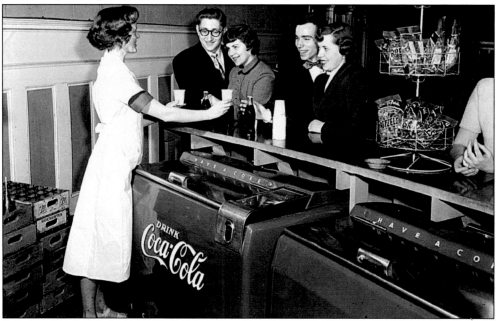

During the night's entertainment at the Stardust Room, it was really hip to visit the refreshment stand. Later you might drive to the RKO Palace for a movie, go bowling, or check out lovers' lane along Durand Eastman Park. (Courtesy Rochester Municipal Archives.)

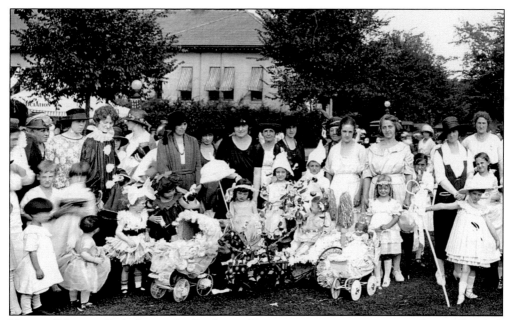

Visiting Edgerton Park during the Rochester Exposition meant wearing your finest. The park grounds bordered Dutchtown as well as more upscale neighborhoods. In this photograph, taken in the 1920s, children and their strollers are highly decorated, suggesting there might have been a children's pageant. Jefferson High School was later built on the grounds and was well attended by Dutchtown teens. (Courtesy Rochester Public Library.)

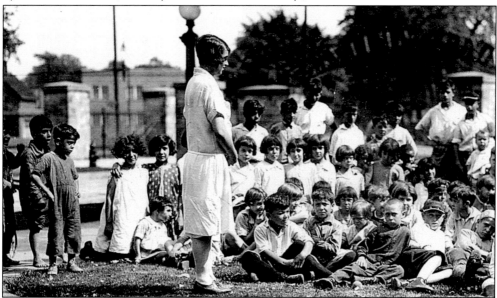

Children listen to a storyteller on the lawn at Edgerton Park in the 1920s as part of the Rochester Playground Library, a program where librarians held story hours in various playgrounds around the city. During the exposition days, some of these boys earned money during equestrian events. "The horses came by railroad car into the Brown Street railroad yard. They would offer us boys 10 cents for each horse we would walk over to Exposition Park," Gene DellaPorta recalled. "Boy! We could not wait for those trains to come!" (Courtesy Rochester Public Library.)

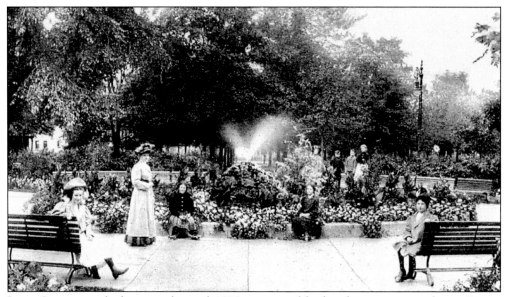

Jones Square was laid out in the mid 1800s as a neighborhood commons similar to Brown Square. Situated at Jones Avenue and Frank Street, it was, by 1900, the garden center of Rochester; the park commission planted thousands of bulbs around the beehive fountain. The square was used for immigrant festivals, such as the Madonna della Libera, and for concerts sponsored by the Italian benevolent society, Bersagliere La Marmora. "There were always bands playing on Saturdays," Gene DellaPorta recalled about the 1920s. "Our delivery horses got scared when we went by from all the banging on drums and cymbals."

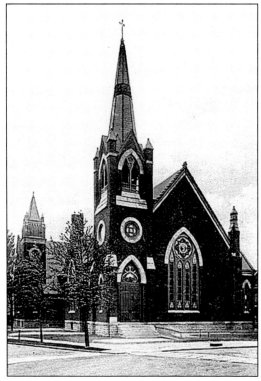

The Trinity Episcopal Church at North Plymouth Avenue (formerly Frank Street) and Jones Street replaced the congregation's 1846 edifice at Plymouth Avenue and Commercial Street. It opened in 1881. The First Assembly of God later used this church. Jones Square opens beyond it.

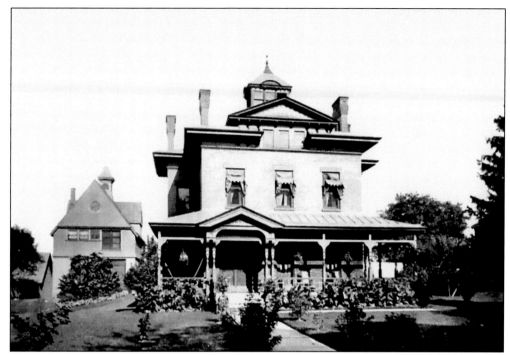

The Lake Avenue district was the envy of many Dutchtown residents. Its grand mansions provided jobs as housemaids, gardeners, coachmen, craftsmen, and masons. Pictured is the residence of Charles Cunningham that stood at 130 Lake Avenue, south of Lorimer Street. Cunningham worked in the family carriage-making business on Canal Street.

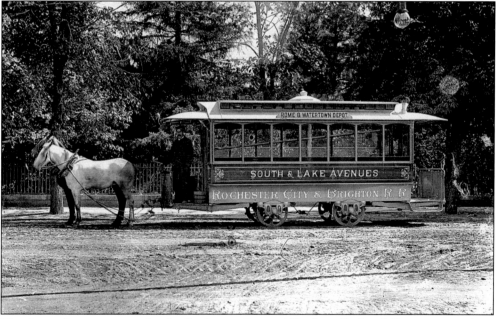

This horse-drawn streetcar for the Rochester City and Brighton Railroad Company ran along South and Lake Avenues. The photograph was taken between 1893 and 1899. These cars provided service to Ontario Beach Park. (Courtesy Rochester Public Library.)

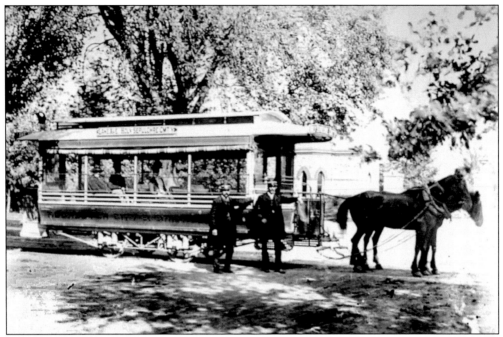

Another horse-drawn streetcar, pictured in the 1880s, was in service along Lake Avenue, primarily to Holy Sepulchre and Riverside Cemeteries. Dutchtown residents could board at Five Corners.

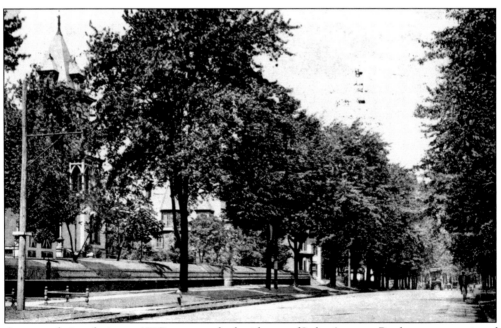

A postcard view dating to 1917 captures the lavishness of Lake Avenue. Rochester was a city of many fine neighborhoods, but the majority of city folk were working class. The industrial giants that amassed fortunes in film, clothing, and optics did so on the backs of laborers who often worked 10 hours a day, 6 days a week.

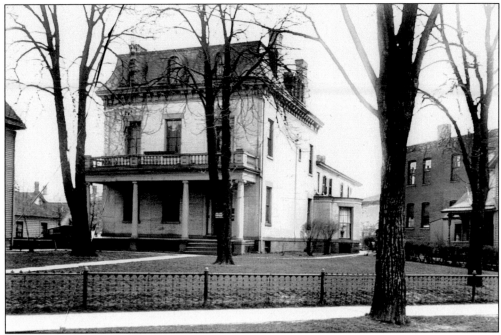

The Whitney residence, pictured *c.* 1916, stood in a large plot at Jay and Magne Streets. It is believed to have been the first house in Rochester with a mansard roof. It was built for Warham Whitney, who established the Whitney mills at Brown's Race in 1827. He is also credited with inventing the first grain elevator. The home was the center of social life in the area for many years. (Courtesy Irondequoit Chapter D.A.R.)

A gentleman stands in the opening of the Emerson Street lift bridge over the Erie Canal on March 7, 1893. (Courtesy Rochester Municipal Archives.)

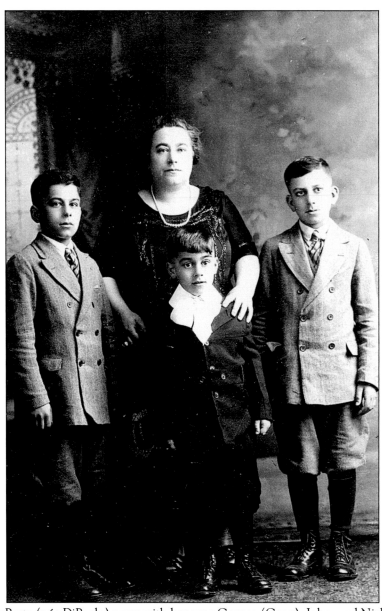

Mary DellaPorta (née DiPaolo) poses with her sons Genaro (Gene), John, and Nicholas (seen from left to right). Mary DiPaolo married Enrico DellaPorta, and they left Casalbordino, Italy, with the DiPaolo, D'Aurizio, and Zimarino families to start new lives in Rochester. In the early 1920s, the families opened DiPaolo Baking Company in an old church on the southeast corner of Frank Street (now North Plymouth Avenue) and Smith Street. They had been in the bakery business prior to this as part of a "consortium" of Italian bakers called Milano Bakery that operated on Ontario Street in Rochester. That group broke up, each member going its own way. One member was DiVincenzo Bakery, now on Portland Avenue. DiPaolo's survived intense, sometimes violent, competition amongst 10 nearby bakeries. They delivered their delicious Italian breads to homes and stores around Rochester in horse-drawn wagons or by foot, carrying the bread in wicker baskets. DiPaolo's became the place to stop after church on Sundays for fresh bread. (Courtesy Thomas DellaPorta.)

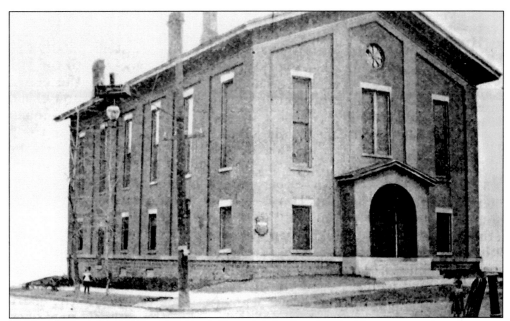

The bakery began in this c. 1852 Frank Street Methodist church. There was a cabinet shop on the second floor, and the sawdust led to many fires. The management was subjected to Mafia-like extortion. Genaro, now in his 90s, recalled, "They slit Vincenzo [DiPaolo]'s face from ear to ear during his delivery. [He survived.] DiVincenzo was reading the paper in front of his home when they drove by and shot him dead. Another bakery they blew up. Finally Tom Zimarino cooled everyone down and the violence stopped." (Courtesy Asbury First United Methodist Church.)

The church was demolished c. 1952, and this new bakery was built. It was expanded several times into this present facility, pictured in the late 1970s. During the 1940s, the management installed a bulk storage system that did away with handling sacks of flour. A huge flour-storage tank was installed with pipes leading from it to the dough mixers. The system was the first of its kind in Rochester and continues in use today. Four generations later, DiPaolo Baking Company remains a family business offering over 70 products, including hearth-baked breads, rolls, and pizza shells. (Courtesy Thomas DellaPorta.)

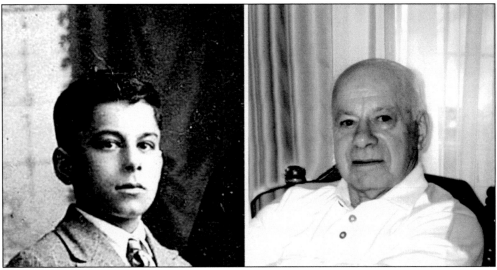

Nearly 80 years separate these two photographs of Genaro DellaPorta (see page 124). A worker in his family's bakery, DiPaolo Baking Company, Gene, now in his 90s, vividly recalls growing up in the area. "I remember the mills quite well. Huge wagons came up Brown Street filled with wheat for grinding. We had six horses for our delivery wagons. In the winter they put cleats on the horseshoes so they wouldn't slip on the ice. I delivered bread to women in their homes. Sometimes they would be doing their wash over a scrub board in a washtub. They would wipe their hands and then squeeze each loaf for freshness." As for ethnic rivalries, he recalled, "We didn't have any trouble with the Germans. There were more Irish where we lived. We got along fine with those Irish boys—O'Malley, Shaunnesy!"

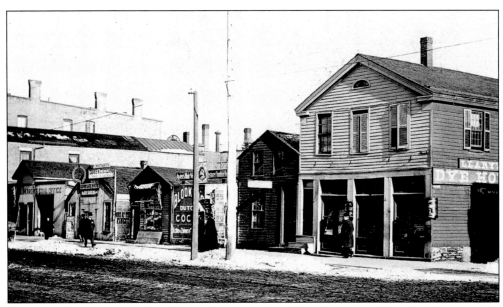

Businesses line the east side of State Street north of Platt Street in 1891. Kodak eventually expanded into this area. To the left is Leary's Dye House. (Courtesy Rochester Public Library.)

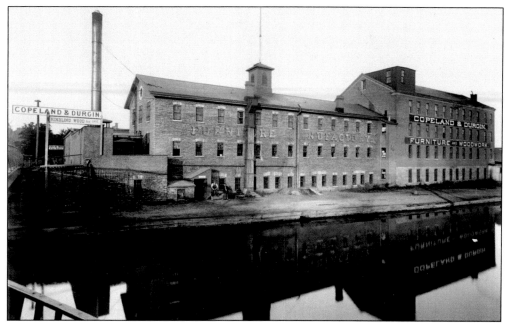

The Copeland and Durgin furniture-making factory and lumberyard was on Jay Street and backed to the Erie Canal. Henry Durgin took this photograph sometime between 1885 and 1900. The image is titled "Works of Copeland and Durgin. View from the east end of Jay Street Bridge." (Courtesy Durgin Photography Collection of the New York State Historical Association, Cooperstown, New York.)

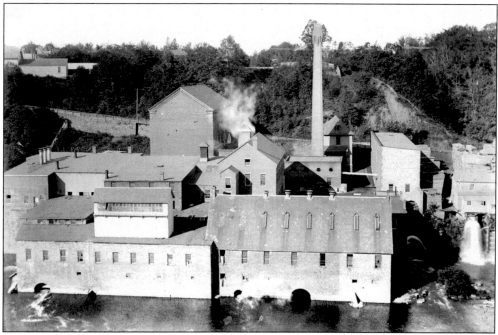

This photograph of the Rochester Paper Mills at the Lower Falls was taken by Henry Durgin between 1885 and 1900. (Courtesy Durgin Photography Collection of the New York State Historical Association, Cooperstown, New York.)

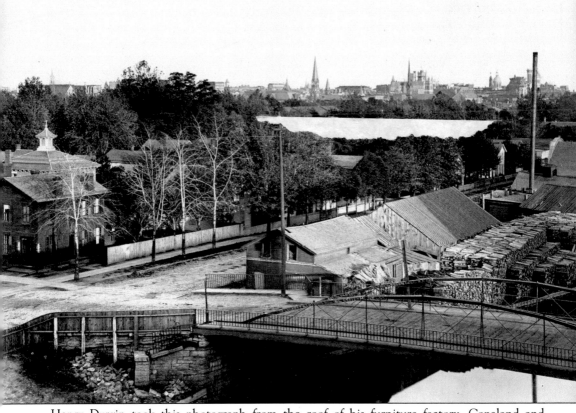

Henry Durgin took this photograph from the roof of his furniture factory, Copeland and Durgin. It is titled "Works of Copeland and Durgin. View from east end of Jay Street Bridge." An elegant photograph, it depicts an uncommonly serene Dutchtown without clattering milk wagons, peddler carts, and bounding children. The city skyline is pierced with the spires and towers of religious, financial, and educational buildings. Dutchtown has always been a special place, one of our immigrant neighborhoods that bore out the expectations of the great American experiment. The mention of it brings a glow to the eyes of seniors who, in spite of the many hardships of growing up, remember it in loving terms. The authors remember how there was always room for one more at Grandma's table, and how when church bells clanged in the New Year, neighbors opened their front doors and rang bells, bidding one another good health and happiness. We hope those of you with ties to Dutchtown will let the young ones know what it was like to live here. Get out the photographs and get the old-timers to tell their stories. All of it is more important than we can imagine. As Dutchtown changes yet again, there lingers deep within its industrial relics the hopes of the pioneers who hauled their heavy mill irons here in sleighs two centuries ago, motivated by unbridled potential. This book is a tribute to them and to all the hardworking folk who followed. (Courtesy Durgin Photography Collection of the New York State Historical Association, Cooperstown, New York.)